Painting Happiness

Painting Happiness

CREATIVITY with WATERCOLORS

Terry Runyan

Leaping Hare Press

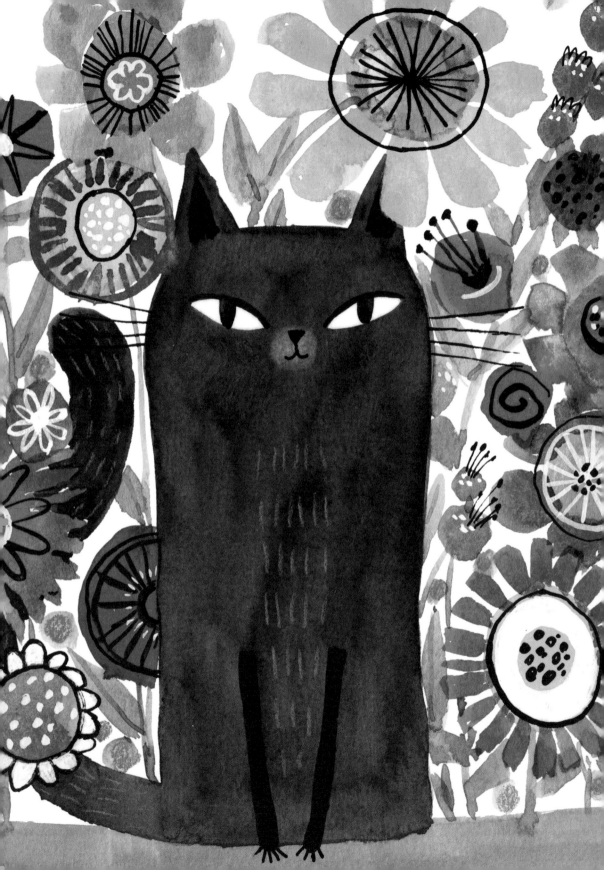

Contents

Introduction

When I was approached by Leaping Hare Press to create a watercolor book on the theme of mindfulness, I was immediately excited, but that excitement was laced with anxiety. Fortunately, I could see the irony of this, so I did not let it stop me. Creating this book would be an opportunity for creative "practice" in being present for the process of unfolding creativity, while allowing my inner-critic thoughts to pass by without engagement.

This book is written directly from the experiences that life has given me. Most of these experiences (including that of writing this book) involve riding a wave from the flow of the paintbrush through the inner-critic voices and back again. All the while, I have had to develop a knowledge of my innate well-being and creativity in order to learn how to ride and be with that wave.

Like most of us, I started creating as a child. I received praise for my creativity, but as I got older I started getting a sense that I wasn't good enough. I'm not sure where this perspective came from, but it stayed with me for decades, resulting in me quitting art for long periods of time. It was not until I was trying to figure out what to do with my life in my mid-twenties that I first came across the career of illustration.

Despite my doubts, I gathered together a portfolio from the few art classes I had taken over the years, and submitted it to San José State University in California, where I grew up. To my surprise I was accepted on a design and illustration course, but secretly wished the school would burn down before I got there. My insecurity (my inner critic) was loud and trying its darnedest to keep me safe. But I kept moving forward.

After graduating, I was recruited by Hallmark in Kansas City, and spent the next thirty years as an in-house illustrator. This was an amazing time, but my inner critic accompanied me all the way. I learned in school and in my career to move as quickly as possible to try and stay ahead of the critic, and mostly I was successful, with a high production level and an eagerness to try new things. All the while I felt a bit like a fraud. I had a major case of "imposter syndrome," with perfectionism and an underlying need to prove myself journeying with me as I moved through my projects and assignments.

Toward the latter part of my career, I became more and more interested in exploring my own art, and in October of 2016 I retired from Hallmark to follow this path, wherever that would lead. This opened the door to a fuller awareness of how the inner critic was affecting me, and a year into my retirement, producing large-scale non-objective paintings, I seemed to be at a crisis point. I didn't know what any of it was for. I was adrift.

It was at this point that I immersed myself again in some of the more helpful pursuits I had when I was younger. These came together as a basic interest in wanting to know who I am, and who we all are. I couldn't simply be this mass of ups and downs depending on the whims of that inner voice, right?

On some level, I knew that no matter what the inner voice was saying, my worth couldn't possibly be determined by what I did. I delved deeper and deeper into this, and emerged on the other side with a recognition of my own and everyone else's inherent well-being, creativity, and value. This understanding is the foundation from which I both create and share. Out of this the creative encourager was born.

Throughout this book I will be encouraging you to keep showing up and to keep creating, and reminding you that what you are expressing through your art does not mean anything about you personally. It says nothing about your worth. Bearing this in mind frees us up to explore, make a mess, start without a plan, and be present for the process. It also helps us to see the inner critic for what it is—simple habits of thought and conditioning—not anything that needs to be listened to or engaged with. We can let it pass through us and keep playing with what is at hand.

Terry Runyan

1

Why Create?

Creativity is a constant

Creativity never sleeps, and we often continue our creative adventure
in our dreams. Even breathing is a creative activity, revealing something
new in each moment. When we understand creativity as an ever-
present movement, we can stop concerning ourselves with whether
we are creative or whether we feel creative. This may be a very different
way of thinking about creativity, but try it on for size. You will begin to
notice that everything is creativity in action. Creativity is movement.

What creativity shows us

Creativity is an unfolding mystery that can surprise us as we move
forward. It reveals that anything is possible, that each moment
something new is happening. It might feel similar to something
we have experienced before, but that memory doesn't actually
relate to what is happening now. Unwittingly, we tend to fall back
on our past experience as a reference point and look for similarities.
But what if we set that aside for a moment and really pay attention
to what is new and unfolding now? Imagine the possibilities that
are constantly opening up.

Why daily practice?

I have found that showing up daily to create has not only increased my productivity, but also made me more aware of my creativity as it unfolds. When I'm feeling inspired, I notice more, but even when I'm not, I notice that creativity happens anyway. This has been an amazing discovery: you don't have to be inspired to create art!

Most of the time, inspiration happens when we put paintbrush or pencil to paper. The act of starting is full of possibilities and ripe for creative flow. Daily practice puts us in touch with this flow. If we engage in this creative "conversation" frequently enough, we can see that it is always present, always available, strengthening our ability to "tap in" to it.

Freedom

When we create, we open ourselves up to the freedom of expression that is our natural state. In the moment of now, we are free of our past and free to ignore any seemingly familiar chatter that floats through our experience. We are not held in place by anything from our memories.

This moment is new.

What an amazing discovery!

A mystery unfolding

Creativity is possibility. Creativity is the unfolding now. Each time we approach the paper, we move into the unknown, but inspiration and creativity are with us always. We may feel it as a rush of pleasurable feeling or a sense of "I can do this." It is a quickening, a sense of being drawn forward, of being invited.

Sometimes when we step into the unknown, the sense of inspiration is drowned out by the familiar thoughts of an inner critic chiming in, but creativity remains present with us, even when we are caught by passing thoughts. We are creativity itself!

The knowledge that creativity is with us and is us as we approach our painting, our art, helps us to keep playing. More often than not, inspiration is experienced as we start to paint, as we apply the brushstroke to the paper. Even if we stay caught by the inner critic's rantings, we are still in the middle of inspiration and creativity. It is impossible to actually be outside of it, no matter what our heads are saying. Recognizing this can free us from concern about needing to be inspired. All we need to do is to show up and pay attention. Inspiration is there.

The joy of the unknown

Most of us see the unknown as something to fear. We are taught to be careful, to learn as much as we can in advance so we can make informed and safe decisions, that not knowing what is about to happen could mean disaster. I am all too familiar with this fear. The sight of blank paper used to terrify me, and I worked long and hard to hone my skills to make sure I had some sense of control. There is nothing wrong with honing our skills, but fear of the unknown can keep us in our comfort zone, playing only with the familiar, trying to stay safe.

There is another way to see the unknown. The unknown is neutral by default. It is not fearful or blissful by nature; it is pure possibility. When seen with an open mind, from the knowledge of our innate well-being and creativity, it is exciting. The unknown is an invitation. It is creativity. It gives us a sense of wonder and curiosity when seen for what it truly is. Everything and anything *is* possible!

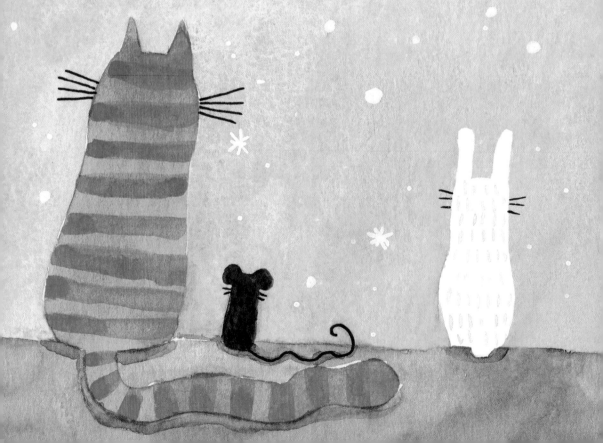

Curiosity and inspiration

Curiosity, inspiration, and the feeling of wonder are born out of creativity itself, springing up from this vast well that is always present and available. Noticing these moments when they happen can shift your art-making to a new level. There is an excitement and anticipation of what might come, together with an openness to go with the flow without directing the waters.

This inspiration and curiosity are already present, and many apparently external things can trigger it into awareness. Nature, a photograph, another artist's work, what you see in front of you… all of these and more can spark a sense of inspiration and curiosity. It is these moments that we learn to pay attention to and move with.

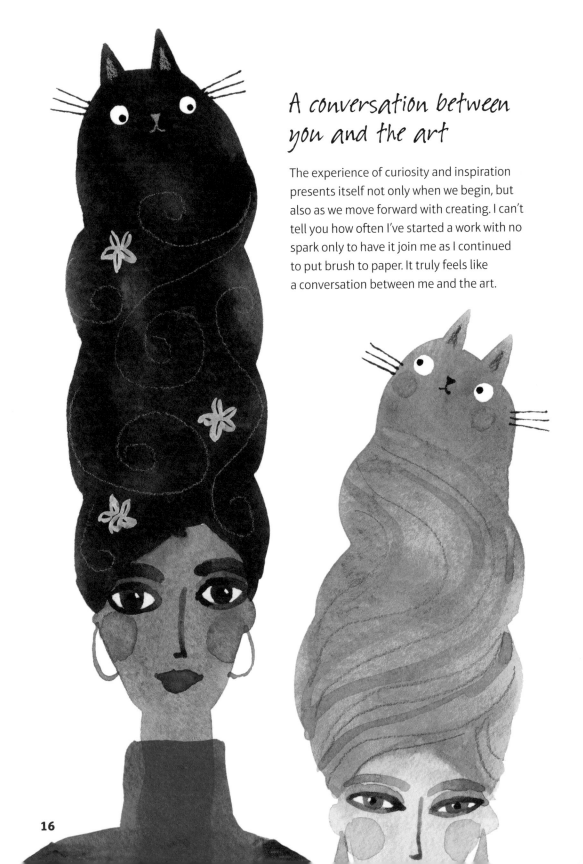

A conversation between you and the art

The experience of curiosity and inspiration presents itself not only when we begin, but also as we move forward with creating. I can't tell you how often I've started a work with no spark only to have it join me as I continued to put brush to paper. It truly feels like a conversation between me and the art.

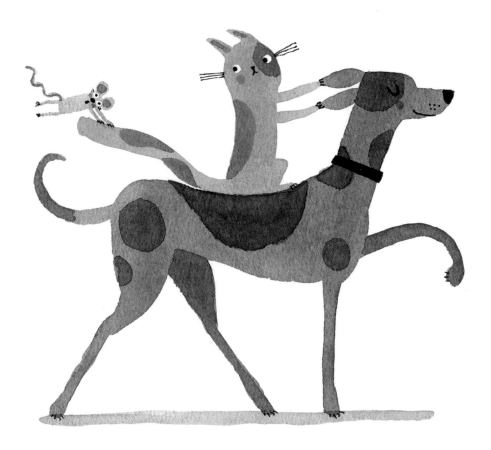

Watercolor can be a very challenging medium

Watercolor is by nature immediate and flowing, and invites us to pay attention as we play. It is this challenge that makes it so engaging. As we open ourselves to the process of mixing paint and water, putting brush to paper, and moving with the mystery of the flow, it is one of the most compelling mediums that I have found.

Remember, five minutes a day is enough to start your journey. The point of this book, beyond playing with watercolor, is to get into action, to get moving. As we move, we become familiar with our materials and more comfortable experimenting and exploring. Your skills will develop naturally as you continue to paint, experiment, and play. Rather than trying to get better, we naturally learn how to move a brush and paint from the joy of painting. We also start to get familiar with the creativity that is always present, available, and flowing in and through us.

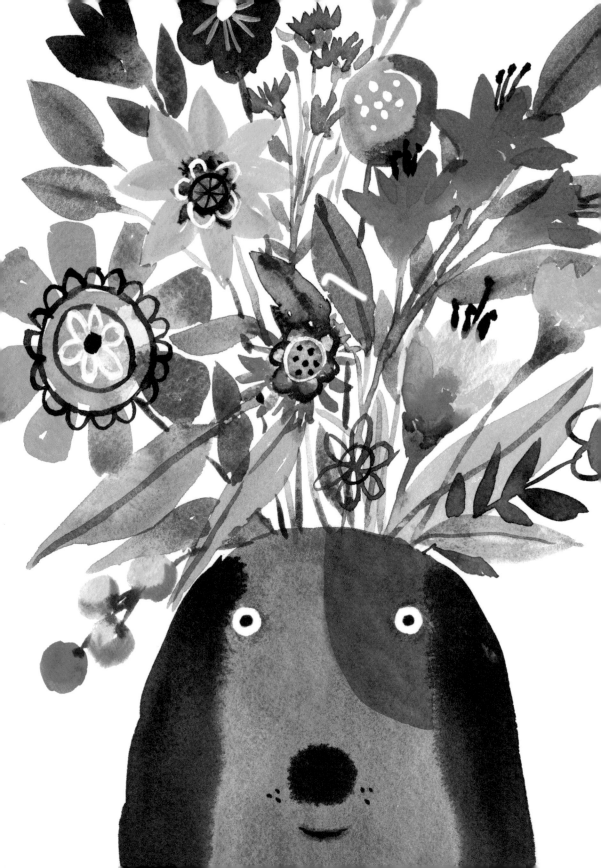

2

About Watercolors

Supplies

You don't need anything special to get started. Use what you have to hand, or purchase a small watercolor set. The most important part is to get started with your painting, even if it is for only five minutes. With that said, watercolors come in a few different varieties. I will talk about the dry type and the tube type here, although I'm mostly a watercolor tube person.

Dry watercolors are what can be found in portable watercolor sets. They are fantastic if you are painting outdoors or traveling, and can be broken down into two kinds: beginner (student-grade) paints and professional-quality paints. The main difference is that professional grade paints have much more actual color pigment than filler. You don't have to work as hard to get rich deep colors. Student-grade watercolors are fantastic to start off with because they are more affordable. As you keep painting you may want to try a professional-quality set of watercolors to experience the difference.

Watercolor tube paints come in student and professional grade as well, with the same main difference being the amount of pigment versus filler. I love using the tube colors because they do not require as much activation with water when fresh out of the tube. They can also be watered down to very light values and reactivated if they dry on the palette. In addition, they give you more paint per tube compared to dry-pad watercolors.

What about colors?

I recommend purchasing either a small set of watercolors or a small range of tube colors. You can mix almost any color from a small set of primary warm and cool colors. The primary colors are red, yellow, and blue, but there are cool reds and warm reds, cool yellows and warm yellows, cool blues and warm blues. I also like to throw in some Payne's gray for the dark darks and often use it in place of black. It can also be helpful to have a couple of earth tones, although these can be mixed if needed. Here is a full list of what I use on my palette. I have other colors available, but I only use those in isolated circumstances. Keeping a simple color palette helps you learn to mix colors so you can create any color imaginable with very few exceptions.

Primary colors

REDS

- Scarlet Lake (warm)
- Alizarin Crimson (cool)

YELLOWS

- New Gamboge or Cadmium Yellow (warm)
- Lemon Yellow (cool)

BLUES

- Cerulean Blue (warm)
- French Ultramarine (cool)

Optional colors

EARTH TONES

- Yellow Ochre
- Burnt Umber (warm)
- Raw Umber (cool)

GRAY

- Payne's Gray
 (blue gray)

OTHER COLORS

- Green Gold
- Terre Verte Green

What about brushes?

There are natural animal hair and synthetic brushes that come in many sizes and shapes. As with paint colors, I keep my choice of the brushes I use very simple. I mostly use round brushes, although many artists swear by flats, dagger and rigger brushes. I will only be discussing round brushes here because they make it possible to achieve a wide variety of marks with a little practice.

Top-of-the-line brushes for watercolor are usually made from natural sable. Although these are what I used for years, I have now switched over to using high-quality "sable-like" synthetic brushes. Opposite, are couple of my current favorites, which come in sets of different sizes.

For larger washes, a size #12 to #16 can be helpful, and these are available in both natural and synthetic.

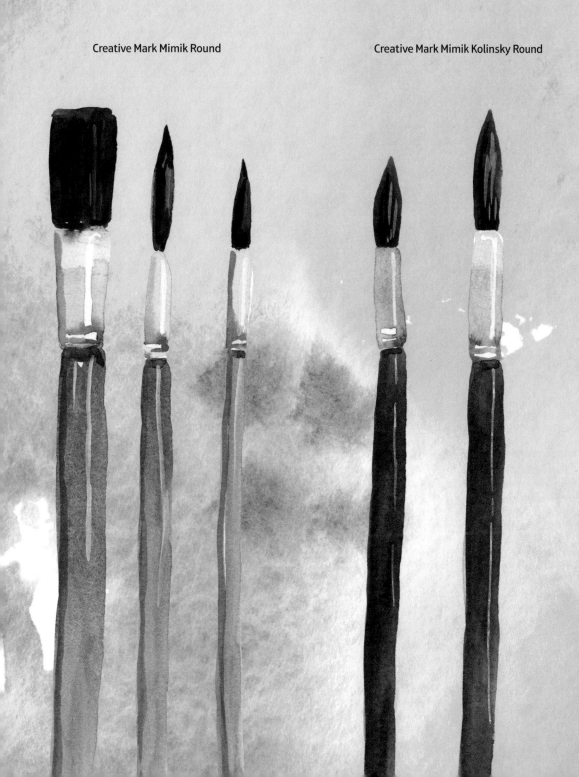

Creative Mark Mimik Round

Creative Mark Mimik Kolinsky Round

And palettes?

Almost anything with a flat surface can be used as a palette, but a white surface is especially helpful when mixing, since the appearance of colors can change relative to what they are next to. I use a plastic palette with plenty of room for mixing, but you could just as well use a white plate.

And paper?

When it comes to watercolor: thickness matters. When you are starting out, any paper will do to get a feel of the brush, paint, and water, but ultimately, getting a thicker paper for watercolor will give you a better result, with much less warping and buckling.

I usually work on 8 x 8-inch (20 x 20-cm) paper pads, although larger sizes are great as well. My new favorite watercolor paper is:

Fluid™ 100 Cold Press 100% Cotton Watercolor Paper
Each pad has fifteen sheets of 140 pound (300 gsm) weight paper. It is bound on two sides, which I love, as this really helps prevent warping and buckling when using larger amounts of water.

For a more affordable alternative, in a larger format, use:

Canson XL 9 x 12-inch (23 x 30-cm) watercolor pad
The paper in this pad comes in the same weight (140 pound/ 300 gsm), and you get thirty sheets.

On keeping a sketchbook

I have never been one to keep a formal sketchbook. I do sketch occasionally when exploring ideas, but most of the time I'm winging it. This has come after decades of creating. Having said that, I do think keeping a sketchbook is a fabulous idea. It is a wonderful place to get those inspiring moments down on paper without the formality of a standalone artwork. It is a place to get messy, to experiment, to write, and to explore just for the fun of it. We can then take that same energy to a new painting, and make sure that we don't lose the spontaneity that we explored in the sketchbook, by not concerning ourselves with the outcome, and staying present with the process.

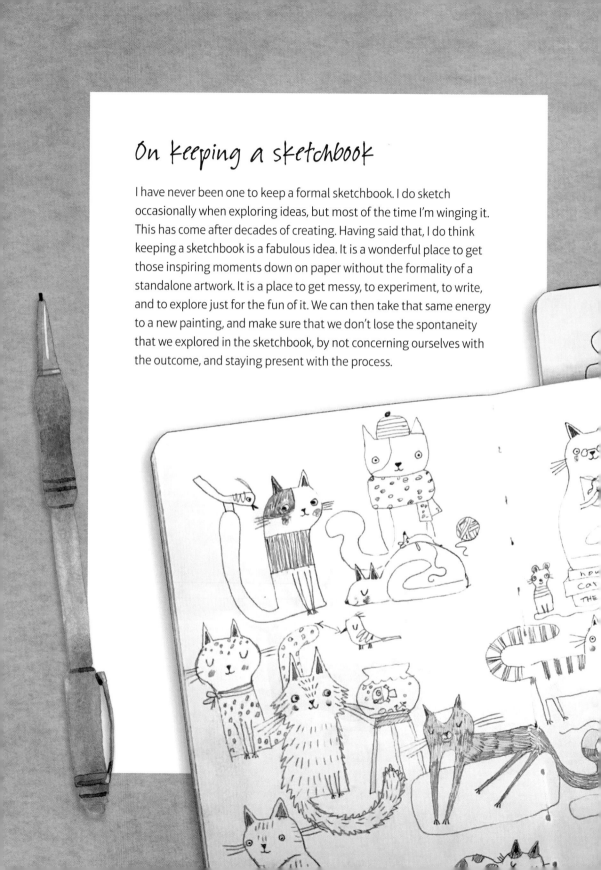

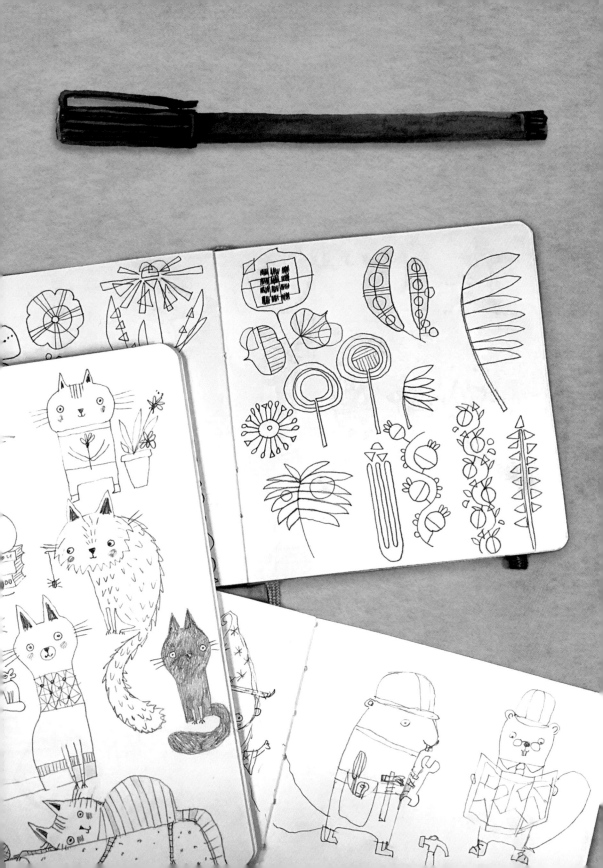

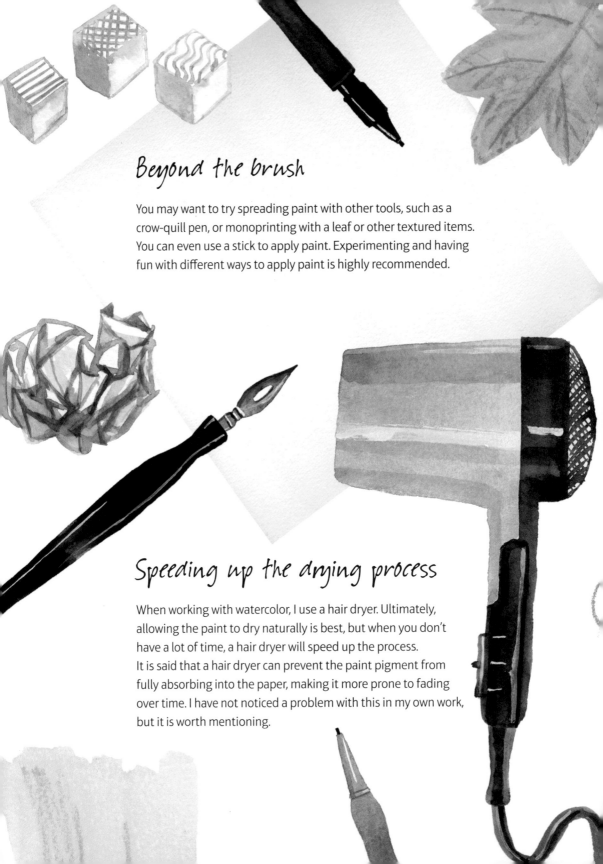

Beyond the brush

You may want to try spreading paint with other tools, such as a crow-quill pen, or monoprinting with a leaf or other textured items. You can even use a stick to apply paint. Experimenting and having fun with different ways to apply paint is highly recommended.

Speeding up the drying process

When working with watercolor, I use a hair dryer. Ultimately, allowing the paint to dry naturally is best, but when you don't have a lot of time, a hair dryer will speed up the process. It is said that a hair dryer can prevent the paint pigment from fully absorbing into the paper, making it more prone to fading over time. I have not noticed a problem with this in my own work, but it is worth mentioning.

On watercolor pencils

Watercolor pencils are a fun and versatile way to explore drawing, and they are water soluble. This means that adding water will turn them into a watery color. I particularly enjoy using watercolor pencils on a wet surface. This makes the pencil smooth and buttery, and enhances the color. It is also a bit out of control, like most watercolor, and so many joyous surprises are possible. You can also wet the pencil first before applying it to the paper; this has a limited but similar effect to working on wet paper.

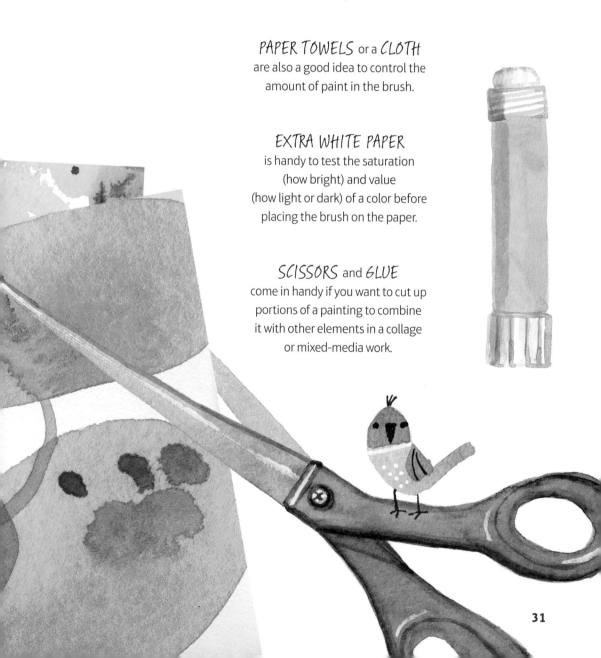

Other handy tools

You will want to have at least one, but preferably two, water containers close to hand. The first container can be used to clean off most of the paint from the brush. The second container, filled with clean water, can be used to finish the rinse and add water to your next color.

PAPER TOWELS or a CLOTH
are also a good idea to control the
amount of paint in the brush.

EXTRA WHITE PAPER
is handy to test the saturation
(how bright) and value
(how light or dark) of a color before
placing the brush on the paper.

SCISSORS and GLUE
come in handy if you want to cut up
portions of a painting to combine
it with other elements in a collage
or mixed-media work.

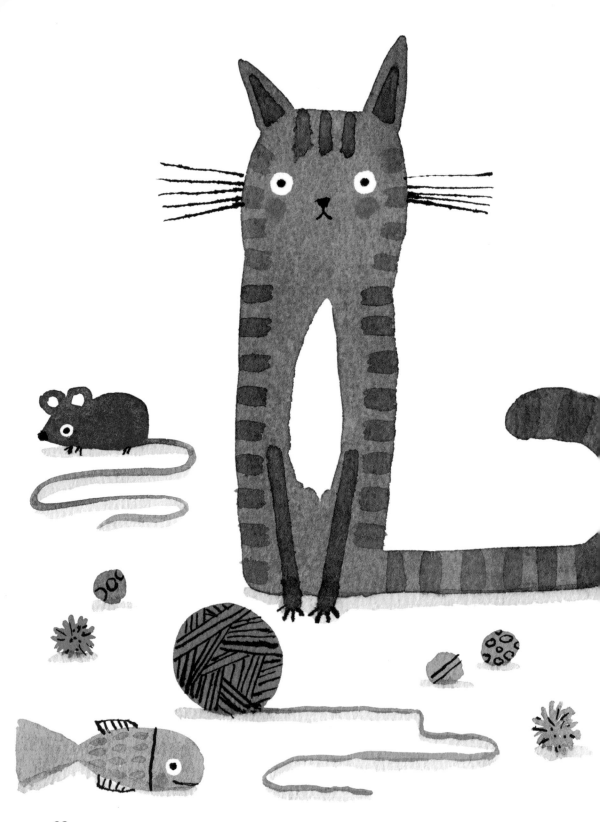

3

What Stops Us

The inner critic

There are several things that can stop us in our tracks or keep us from enjoying the practice of creating art. Let's call these things the "inner critic." It shows up in a vast number of ways, often as well-rehearsed thoughts developed out of misunderstanding. It only sees problems and is activated when what is going on now jogs a memory from the past or we become uncertain of what is coming next. We often don't know what that memory is, but when it is reignited in our mind, it is experienced as true even though it has nothing to do with what is now present.

Such thoughts feel real because we are not seeing them for what they are: simply habits that we follow out of familiarity. They can paralyze us if believed and nurtured. As we move forward in the book and play with our art, these thoughts will show up in very convincing ways, but we can allow them to pass by without having to engage, wrestle or confront them. For me, they are like clockwork. Whenever I start something new, these thoughts pop up. These familiar thoughts can feel comfortable even while making us miserable. Seeing this clearly, coupled with the realization of our innate well-being is completely transformative to how we experience creativity and life.

Here are some examples of how the inner critic can show up.

Fear of blank paper and wasting materials

Fear can show up and keep us from moving forward when we approach a blank sheet of paper or use art supplies. Maybe you don't want to waste materials. It is good to keep in mind that painting is a learning process, and any materials you use are employed for this lovely purpose, as well as for the joy of exploration.

You also may be stumped on what to paint. On page 52, I share a list of prompts, and talk about using what we see and research to spark inspiration. Maybe you are afraid of what might show up. Approaching an empty sheet of white paper can indeed be daunting, particularly if our expectations are high or we are afraid of what might happen. This is a common occurrence for most artists. There is nothing like jumping in with curiosity and no expectations to free you up.

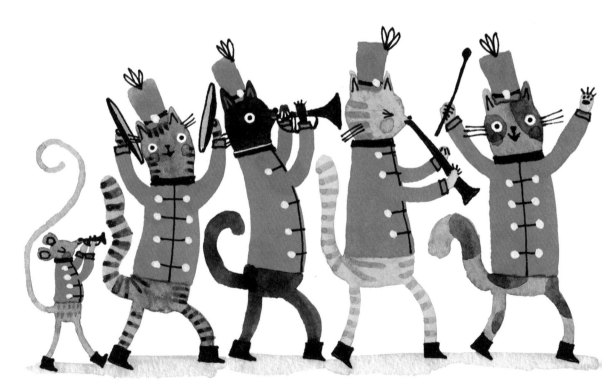

Throughout this book I have included some warm up exercises to move us past this fear.

Try looking at the paper as an invitation to splash paint around, to play, rather than something that needs to be the next masterpiece. This can really help us to jump in. The more we move forward without expectation, the less the white paper will intimidate us.

The nature of creativity itself is a movement into mystery. We don't really know what is going to happen as we move forward. As already mentioned, this can seem scary or it can be exciting, depending on our point of view. I find it very helpful to take a stance of curiosity, an openness to see what happens. Curiosity replaces fear of the unknown, and we start to enjoy the mystery.

Remember: what we create isn't us. It is a powerful thing to realize that our worth is inherent in who we are. We start out as our beautiful selves, to which nothing needs to be added. From this perspective we can create without the burden of the art meaning something about us or having anything to do with our worth.

This is creative freedom!

Perfectionism

The idea of perfectionism is based on a misunderstanding, as there is no such thing as a lack of perfection. There is perfection in whatever appears to be imperfection.

→ Our perfection is inherent to us.
→ Our perfection is our innate well-being, our innate creativity.
→ Nothing we do can add or subtract from this perfection.

With that said, the perfection of imperfection can be seen in an explosion of creativity, in painting outside the lines, in the unplanned spontaneous marks we make, in new colors that blend by surprise. These moments are the perfectly imperfect stuff that creativity is made of.

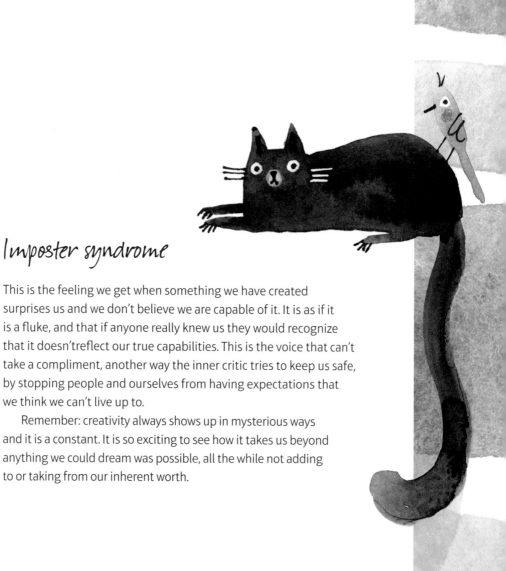

Imposter syndrome

This is the feeling we get when something we have created surprises us and we don't believe we are capable of it. It is as if it is a fluke, and that if anyone really knew us they would recognize that it doesn'treflect our true capabilities. This is the voice that can't take a compliment, another way the inner critic tries to keep us safe, by stopping people and ourselves from having expectations that we think we can't live up to.

Remember: creativity always shows up in mysterious ways and it is a constant. It is so exciting to see how it takes us beyond anything we could dream was possible, all the while not adding to or taking from our inherent worth.

There is no such thing as a creative block!

It is often said that artists go through times when they are creatively blocked or have artist's block. This idea is shared and taught as something real that happens to all of us and is to be expected when we are on a creative journey. As I said before, creativity is a constant ever-present flow that has no beginning or endings. When we are experiencing what is referred to as a "creative block," what is actually happening is that the voice of our inner critic has become forefront in our minds and has distracted us for a moment, a day or a week with the idea that we are blocked. It is important that we remember that creativity is still alive and well even during these moments of confusion, and that our habitual thoughts can be allowed to pass by. Moving ahead with brush or pencil on paper, going with the flow, and not engaging with passing thoughts, will show us that creativity is happening no matter what our old thoughts about being blocked may be.

I've mentioned that creating something doesn't have to take a lot of time. It is beneficial to keep your hand in the game, even if for only five minutes. A quick sketch or scribble or painting some watercolor blobs, lines or dots can be enough to keep the conversation going with the creativity that is always with us.

Taking these short periods to create something new can prove to be extremely beneficial in our day and life. They are moments where you can set aside any inner-critic thoughts that cross your mind. They can be seen as short practices in mindfulness rather than creating with expectations of greatness. Give it a try. It is amazing how often five minutes can turn into a beautiful exploration that rejuvenates you for the next "thing on the list."

The "hate it" phase

Something I have noticed over years of creating is that I almost always go through a "hate it" phase. I might or might not have a prompt or idea at the start of a painting, or just move with the next impulse, but there comes a time, a moment in the process, when my inner critic gets very loud protesting things are not going right. This is like clockwork for me. During these times, I literally believe I hate what I'm doing. Luckily, I've come to recognize these times as old habit thoughts chiming in, trying to keep me safe from what might or might not happen. Because I know what they are, I let them move along, often with a chuckle, and continue with what I'm creating. Like all such thoughts, they pass by more quickly if we recognize them, do not engage, and continue with our process.

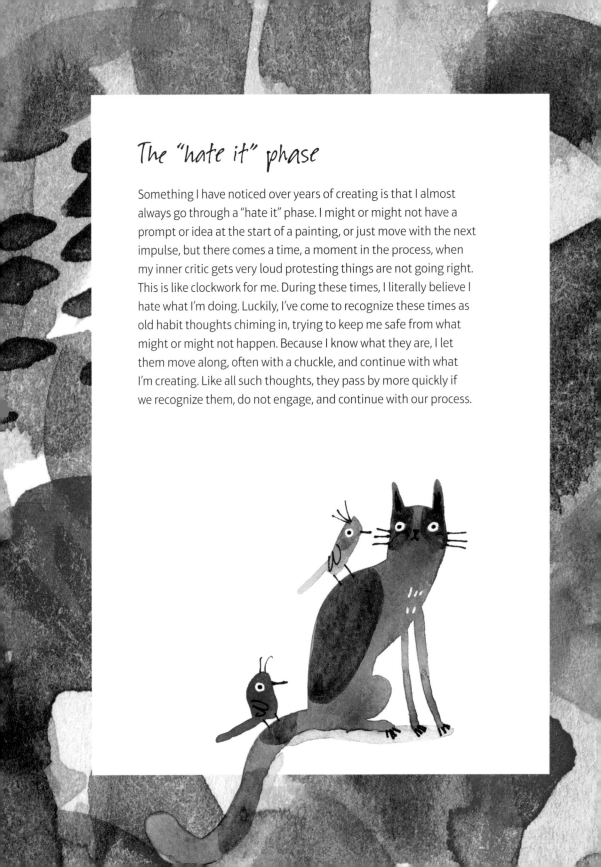

Final thoughts on the inner critic

What if there is no such thing as failure? What if imperfection is perfection and the creative magic is found in what we think are mistakes? I can't tell you how many times my mistakes ended up leading me in new, exciting directions. Even when something doesn't work out, you can see it as an amazing part of the journey of learning something new. Each experience adds to our ever-growing creative exploration and can be treasured as part of the process.

I offer these reminders about navigating the turbulent inner-critic thoughts and feelings to encourage you back to your art, to where and what you are doing now, to stay present with the process and keep it light and fun. Notice the inner critic moving past like a cloud floating through the sky. Its voices are temporary, wispy memories that have no relationship to now.

Every moment holds new, clean, and clear possibility.

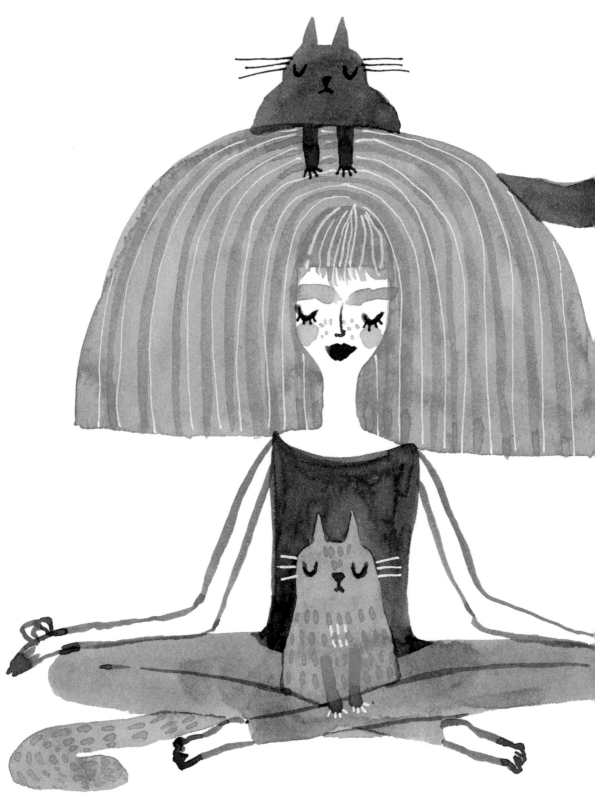

4

Mindfulness and Being Present

Paying attention

As you read this book, take a moment, now, to allow yourself to be fully present with the process of reading these words. I like to call this "present awareness." Likewise, as you paint, take time to focus in on the color, the brush swirling in the water, mixing the paint, the feel of the paper, the touch of the brush, and the stroke of color. Each moment is a gift, a new experience, and all there truly is.

As we sink into present awareness, we can explore the joy of what is being revealed as it is happening. Ideas from the past and future will certainly bubble up, and we can mindfully see them for what they are now as we continue paying attention to what is present. I'd like to go a bit more deeply into a few things that you might notice or want to pay attention to. These ideas are reminders of our natural state.

Curiosity

Curiosity is one of the ways that creativity makes itself known. We may be looking through Pinterest or Instagram and find ourselves curious about something. Maybe we want to explore and know more about an artist, or there is something in their work that inspires us and we want to learn more. Maybe we are inspired to create something ourselves. These moments are ignition points where creativity pokes through our often automatic thinking. Pay attention to these moments and follow them as they arise. They put you into the unknown, the open learning mode, where creativity thrives.

Inspiration

Like curiosity, inspiration can sometimes announce itself loudly but often sneaks in quietly. It is the feeling of quickening, of being lifted, of finding yourself saying "I can do that" or "I want to try that." Unfortunately, these thoughts are often where it stops. We continue scrolling, passing by, almost unnoticed, these calls, these invitations from creativity itself.

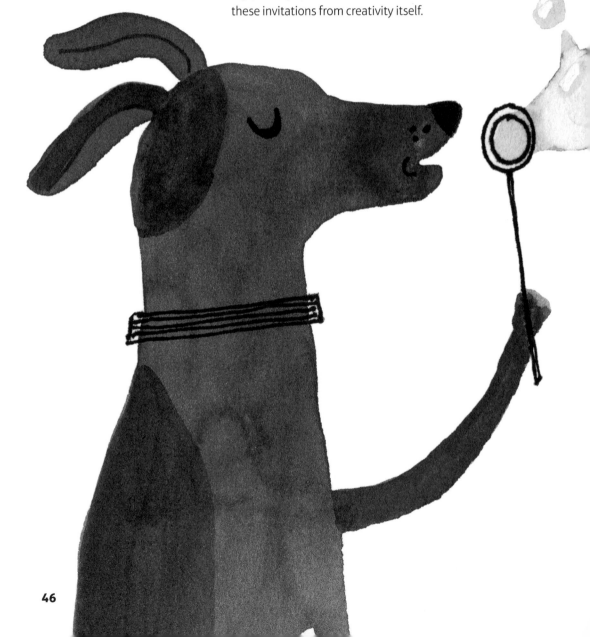

Paying attention to the things that catch our eye, noticing the moments of inspiration, no matter how quiet and nuanced, will make all the difference to your creative output. These moments are bursting full of possibility and ripe for creating something new. Learn to stop scrolling, to move to your paints and paper, and jump in. Explore what is inspiring you just for the fun of it. This is when the magic happens, when the mystery begins to reveal itself. This, coupled with not engaging with those inner-critic voices, will completely refresh your creative time over and over again.

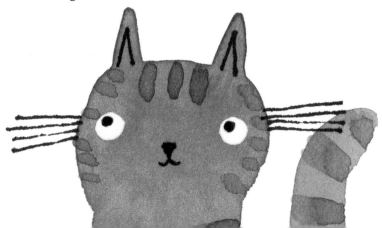

Showing up even when uninspired

Inspiration meets us where we are and walks with us as we step forward. But inspiration often goes unnoticed. We know we want to create something—maybe we are doing a daily practice or we remember how much we enjoy painting—but we don't feel inspired to create anything now. Nothing is coming to mind to create, or everything that comes to mind feels uninteresting. During these times showing up anyway is the magical doorway and invitation for creativity to join you.

I often start a new creative session with a bit of "research" on Pinterest. Looking at colors, shapes, and images can get me started if nothing seems to be moving for me. Where the art goes from there is, as I have said, the mystery unfolding. It can be exciting to see what grows out of the simplest shapes, lines or colors. Even when we never make it out of the "hate it" phase, we have spent time with creativity and this is never time lost. We can view it as our date with our muse, letting go of the outcome, appreciating the process.

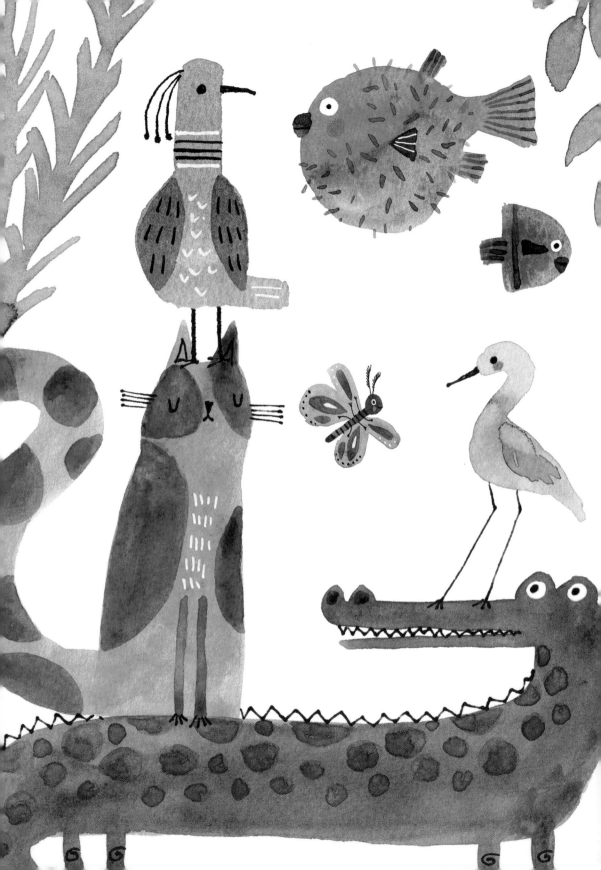

Project 1:

Thirty-day kick-start

Let's jump in to our first project. I invite you to create something daily for thirty consecutive days. The value of daily creating is to kick-start your art practice and put you in conversation with your creativity.

Take at least five minutes and go from there. The amount of time is not as important as taking action. Play with what comes up. Remember it is important to not concern yourself with the outcome during this process. We are not trying to get anywhere in particular. The prompts list is not mandatory but is available if you find it helpful. You can use it to spark an idea or take it literally to paint an object. I always encourage people to follow their own inspiration, whether that starts with a prompt, researching, painting randomly, being inspired by nature, photography or what is on your desk, or simply having something pop into your mind as you move your hand across the paper. The important thing is to start, to stay present, and to see what happens.

DAYS 1–5
Pick one thing from the prompts list.

DAYS 6–10
Combine two different things.

DAYS 11–15
Combine three different things.

DAYS 16–30
Fifteen days of mix-and-match, continuing daily creativity.

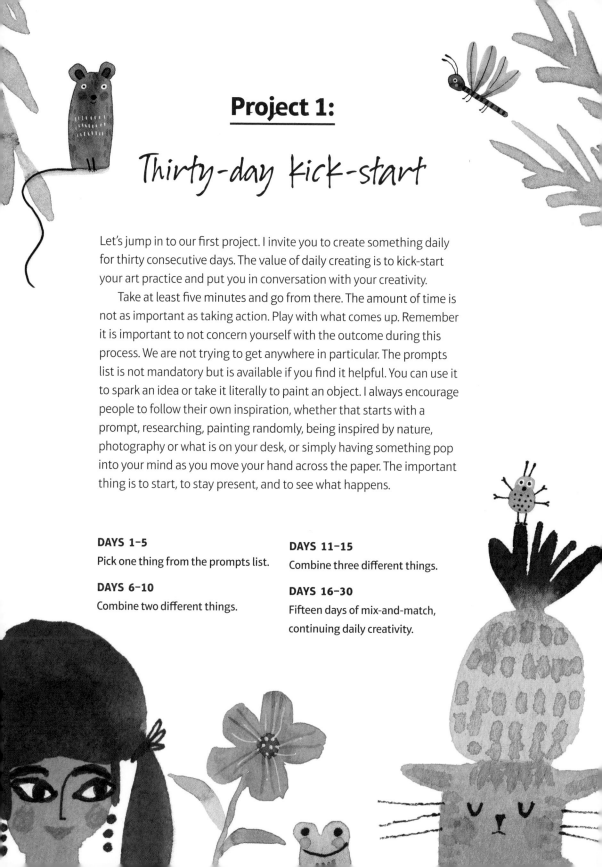

Prompts list

- Boat
- Face
- Dog
- Tree
- Octopus
- Cactus
- Hamster
- Bicycle
- Horse
- Clothes
- Monkey
- Cat

- Garden
- Farm
- Underwater
- Chair
- Chicken
- Fruit
- Pattern
- Pig
- Monster
- Underwear
- Pot plant
- Self-portrait
- Car
- Musical instruments

- King & queen
- Totem
- Knitting
- Dragon
- Squirrel
- Boot
- Zebra
- Glasses
- Kitchen
- Tiger
- Polka dots
- Bear
- Hat
- Toy
- House
- Whale
- Sock
- Angel
- Lion
- Bonsai

- Fox
- Camera
- Curly
- Giraffe
- Building
- Fairy
- Jungle
- Fashion
- Dinosaur
- Family
- Vegetable
- Sports
- Texture
- Sheep
- Leaf
- Butterfly
- Narwal
- Terrarium
- Woodland
- Landscape
- Fish
- Bed
- Camping
- Aquarium
- Birdcage
- Beehive
- Shark
- Flower
- Friendship
- Vacation

- Transportation
- Blue
- Yellow
- Purple
- Black & white
- Red
- Orange
- Ice cream
- Furniture
- Fire engine
- Tree house
- Pet
- Herb
- Insect
- Mermaid
- Unicorn
- Elephant
- Speed
- Flamingo

- Rabbit
- Lazy
- Rain
- Umbrella
- Rocket ship
- Airplane
- Yoga
- Rotary phone
- Tea & coffee
- Zodiac
- Lunch outing
- Beverage
- Slipper
- Dream
- Condiments
- Zoo
- Skunk
- Birdbath
- Water fountain

- Bird
- Plaid
- Quilt
- Chameleon
- Hands
- Feet
- Mouse
- UFO
- Mushroom

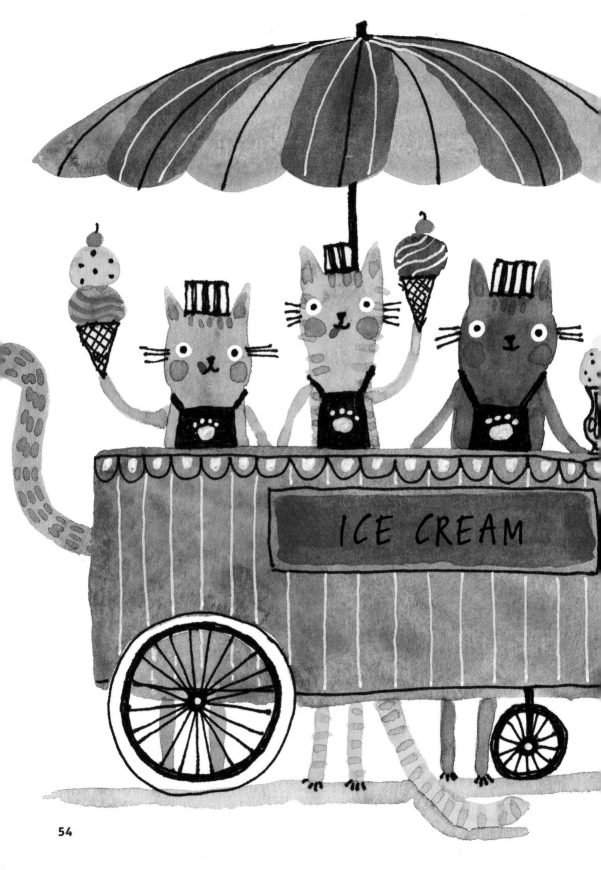

Combine several items from the list or from your
imagination, and you have a story.

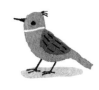
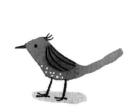
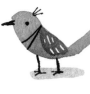

Observation, painting, and drawing

Another great practice for your thirty-day project is observational painting and drawing. Notice things around you and try to draw or paint them without expectations. If it helps, try "blind contour drawing": draw what you see but don't look at the paper. This is also a great reason to keep a sketchbook with you when you are out and about. Go with the intention to paint or draw something during the day. With this intention, something you observe might trigger your creativity. Jotting down ideas or sketching is a great way to capture these moments and use them later in the studio.

5

Let's Paint!

Loosening up

The value of throwing paint around and loosening up can only be appreciated by doing it. Take five minutes to paint blobs or mush colors together. Get messy! This is a great way to start your painting time. Randomness can clear the mind, open your heart to what is possible, and help to put you in the moment.

Remember it is crucial not to concern yourself with the outcome during this process. You are not trying to get anywhere in particular. This is an exploration, a discovery process. If you are rigid in what you are trying to achieve, the door is not open to something brand new, maybe more *you*, to show up. This doesn't mean you won't be working on a cat, for instance, but as you move toward that, try letting go of the ultimate outcome. The surprises that come can often be fresher and different from anything you had in mind.

I personally never know exactly how the brush will flow and it is a delight to see things show up that I could not have anticipated.

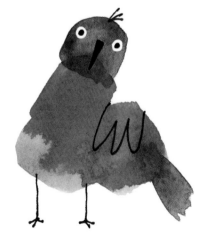

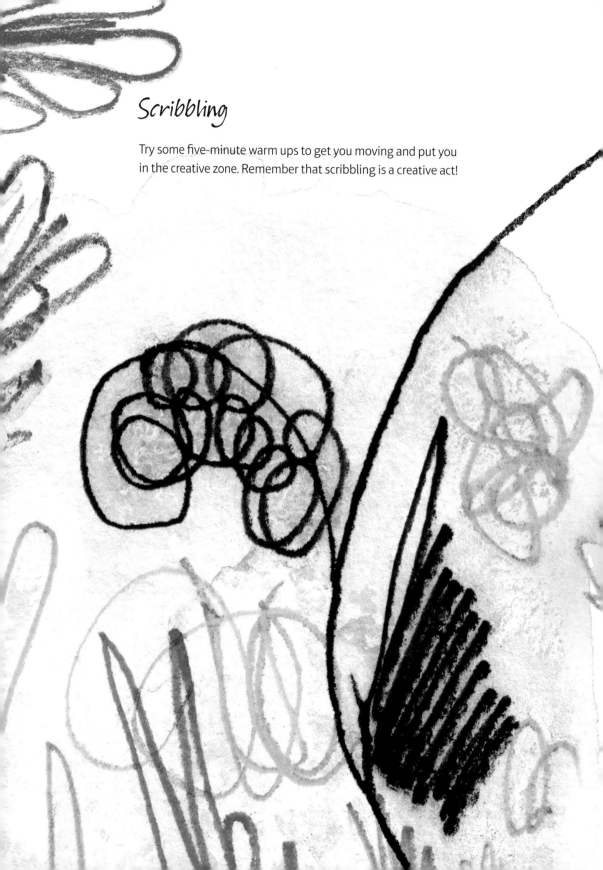

Scribbling

Try some five-minute warm ups to get you moving and put you in the creative zone. Remember that scribbling is a creative act!

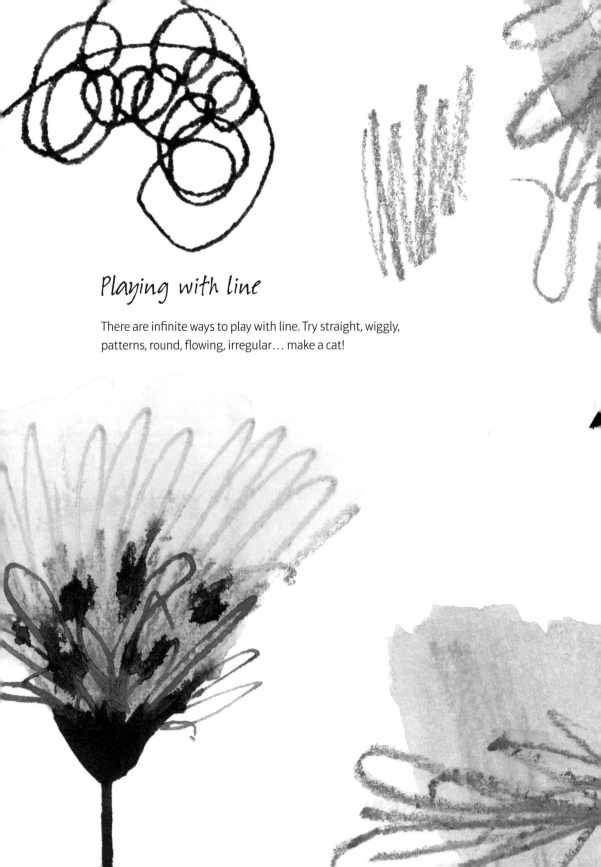

Playing with line

There are infinite ways to play with line. Try straight, wiggly, patterns, round, flowing, irregular… make a cat!

Playing with shapes

Shapes are also infinite! Try using your brush to make a round,
square, and triangular shape. Now cut loose and create irregular shapes.
Maybe a bird…?

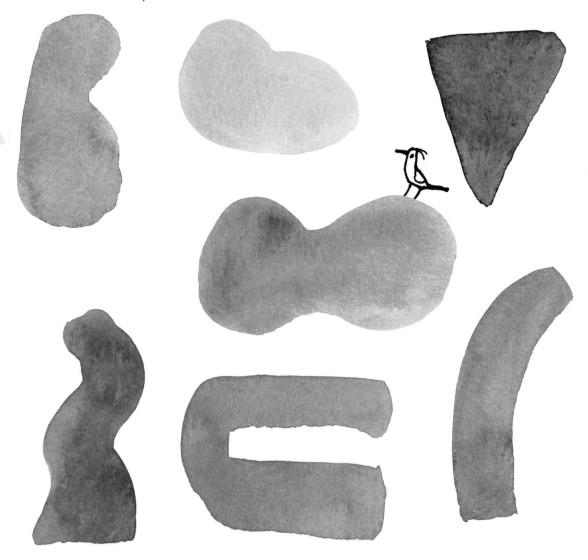

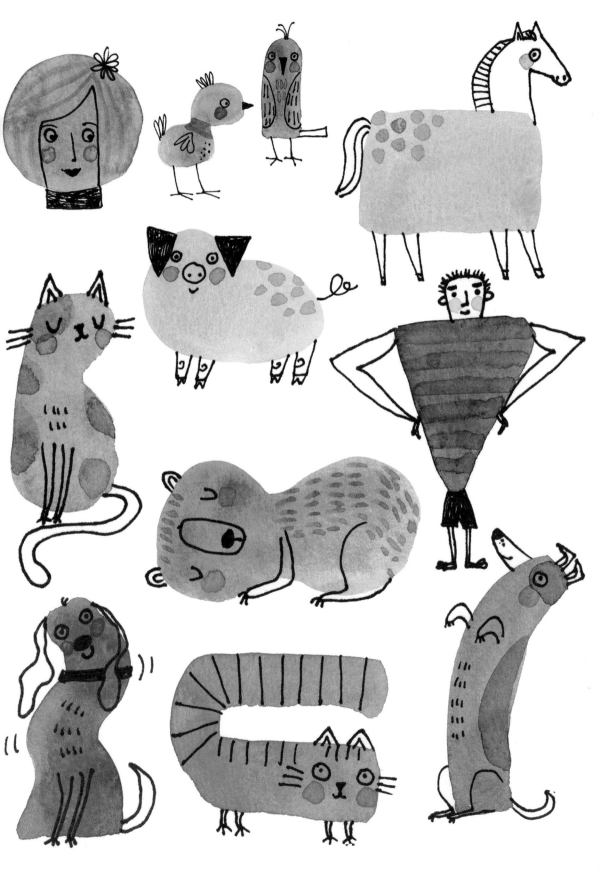

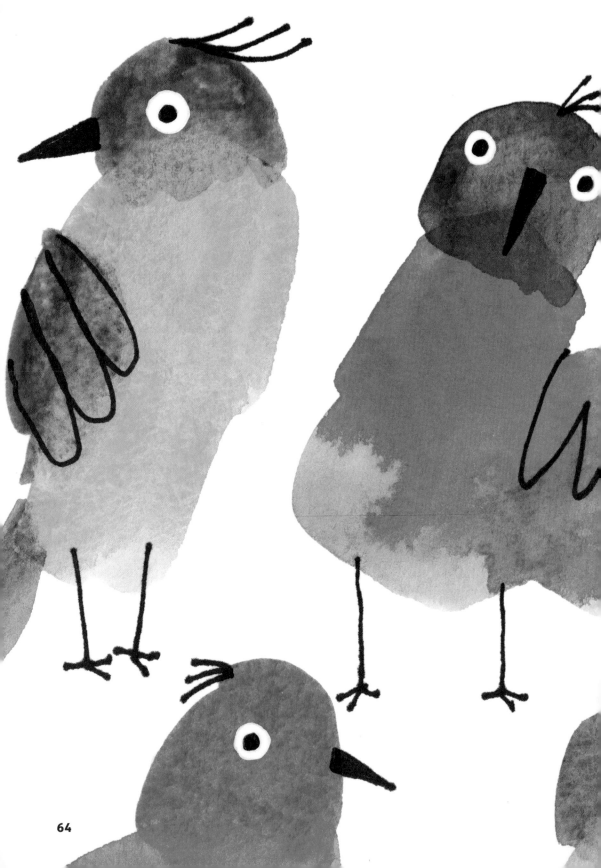

Project 2:

From blobs to birds

Birds come in every imaginable shape, size, and color, and are a great starting point for watercolor painting. Don't worry about the finished artwork, just enjoy the mystery of seeing what happens when the blobs of paint you make turn into birds.

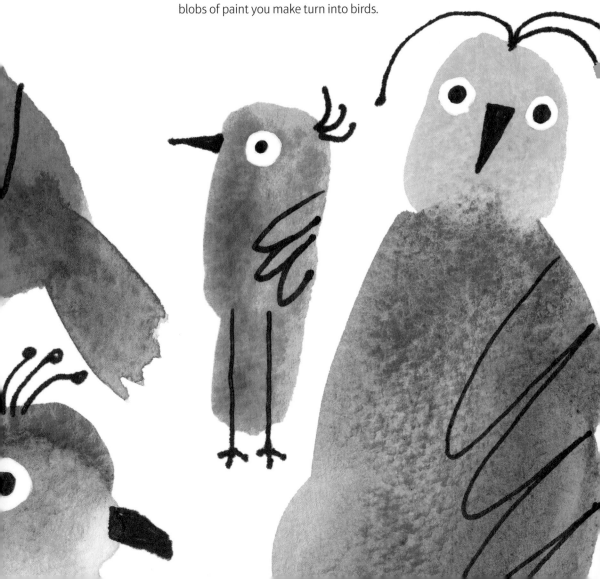

Paint some blobs.

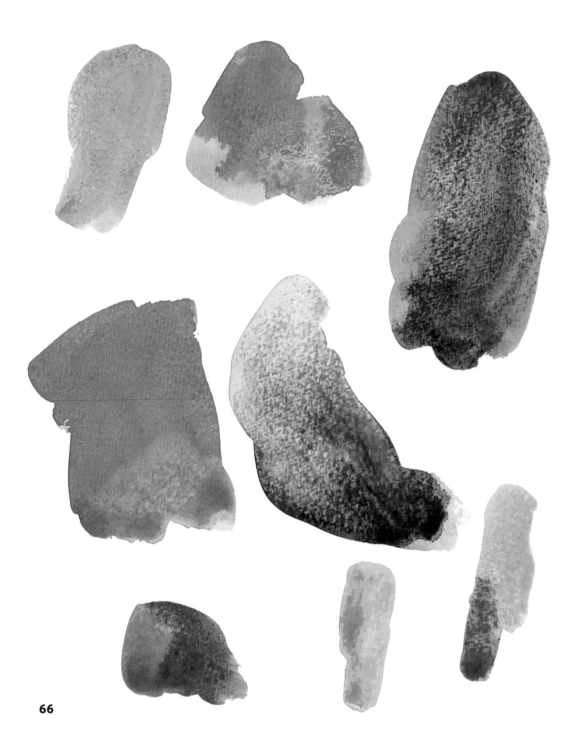

Add some painted details, like heads or wings.

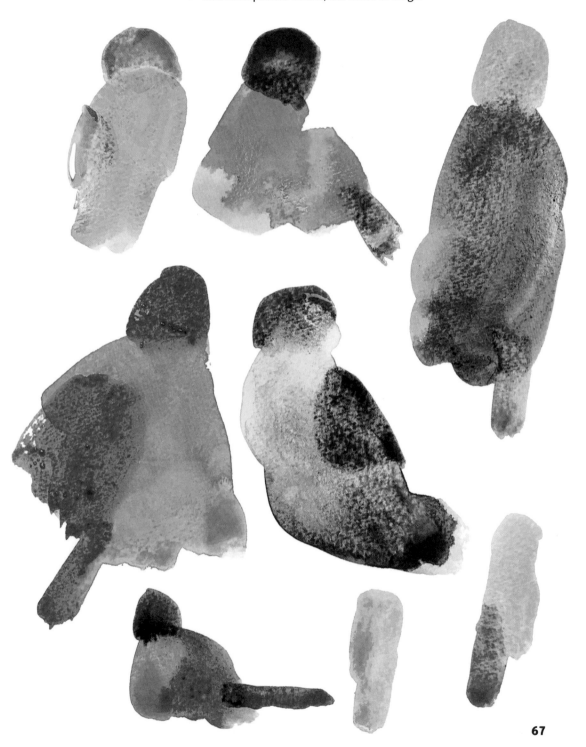

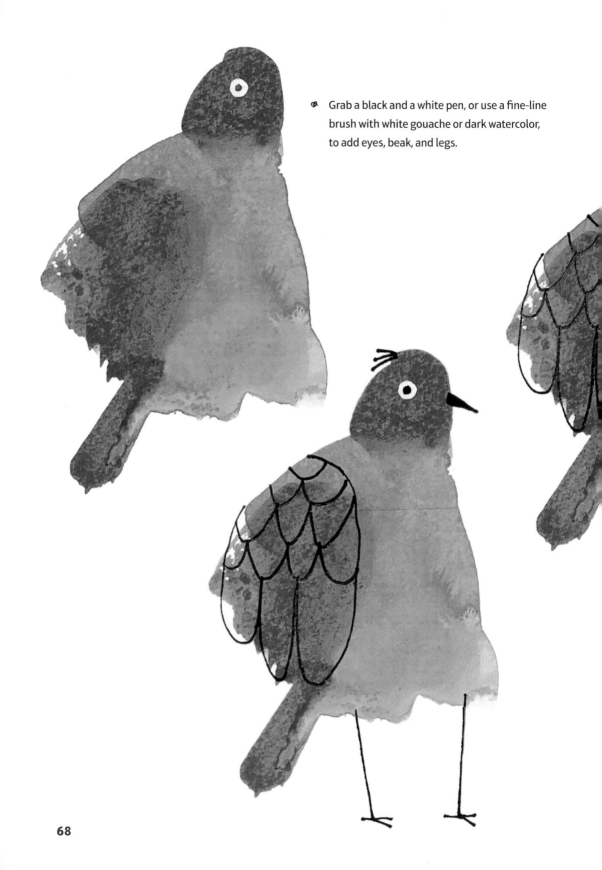

Grab a black and a white pen, or use a fine-line brush with white gouache or dark watercolor, to add eyes, beak, and legs.

Keep adding details.
Perhaps some grasses?
Possibly a branch gift for a friend?

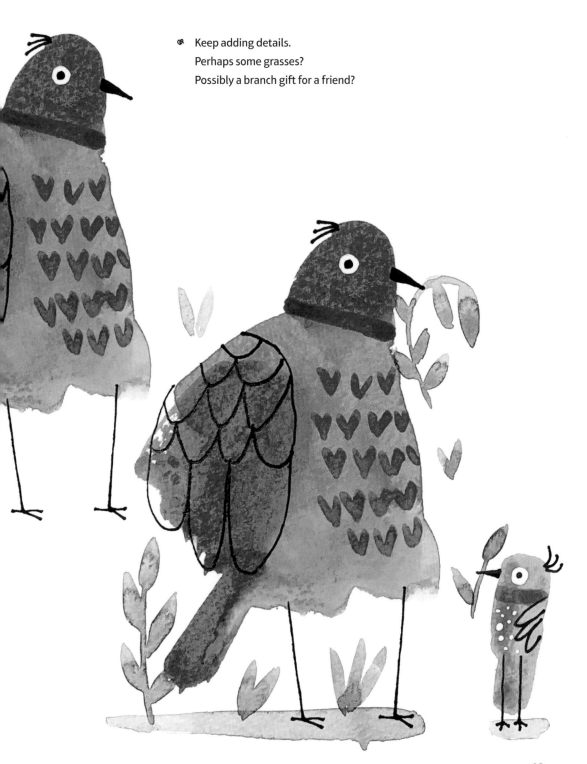

Mixing colors

Keeping the palette simple not only makes working with color less overwhelming, it also teaches us how to mix our own colors. Using primary colors, we can create secondary colors.

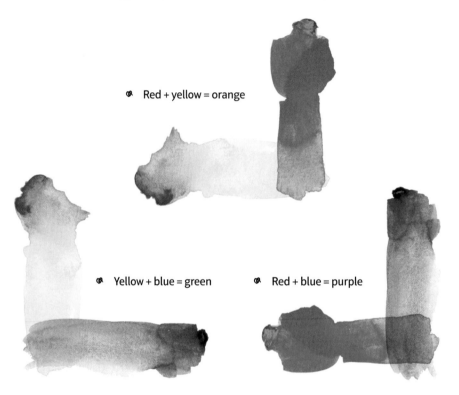

⊛ Red + yellow = orange

⊛ Yellow + blue = green ⊛ Red + blue = purple

The color wheel

The color wheel to the right shows primary and secondary colors. Primary colors—red, yellow, and blue—can't be made by mixing other colors. Secondary colors are made by mixing two primary colors.

Colors directly across from each other on the wheel are complimentary colors. Using complimentary colors together in your art can bring vibrancy and emphasis. Similar colors, which sit next to each other on the wheel, create harmony.

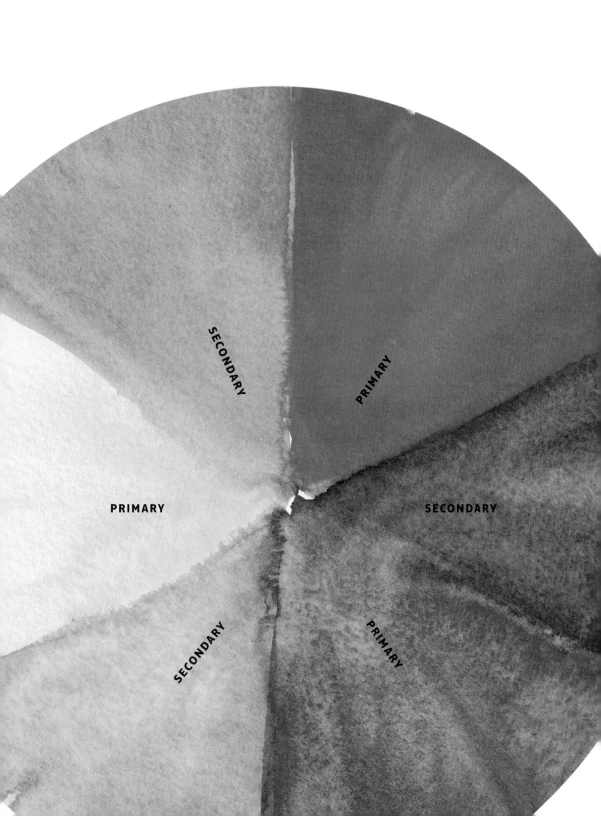

Experimenting with mixing

Using warm and cool colors in different combinations gives a cleaner or a grayer appearance. Generally speaking, mixing a cool red with a cool blue will give you a cleaner violet/purple color; mixing a warm red with a warm yellow will give you a cleaner orange.

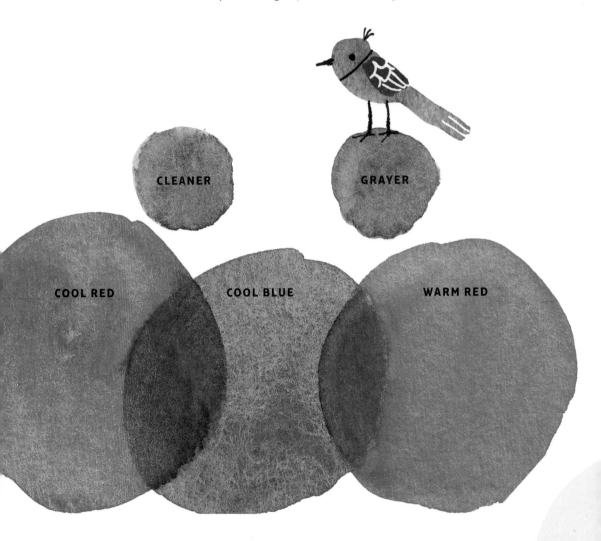

CLEANER

GRAYER

COOL RED

COOL BLUE

WARM RED

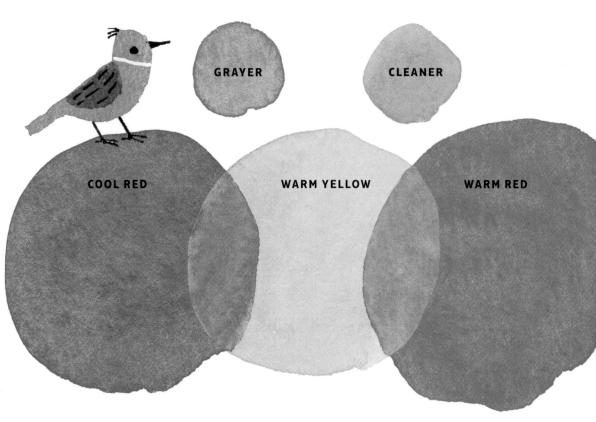

GRAYER

CLEANER

COOL RED

WARM YELLOW

WARM RED

The exception to the rule! Warm yellow has more red in it.
Green and red are opposites, so they make a grayer color.

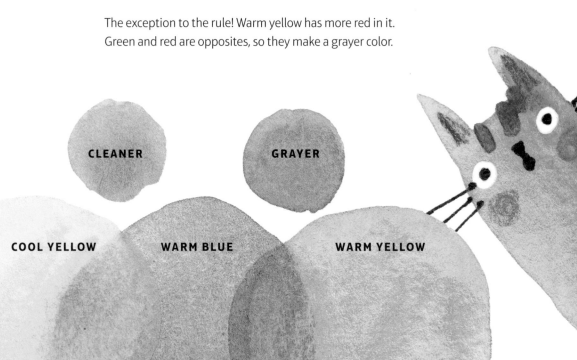

CLEANER

GRAYER

COOL YELLOW

WARM BLUE

WARM YELLOW

Color harmony

A simple way to achieve harmony in a painting is by adding a small amount of one dominant color into each color you are mixing. This may gray the color a bit, but it tricks the eye into seeing the color as more harmonious throughout the painting.

In this piece, I mixed a tiny bit of the reddish-pink color in each cat!

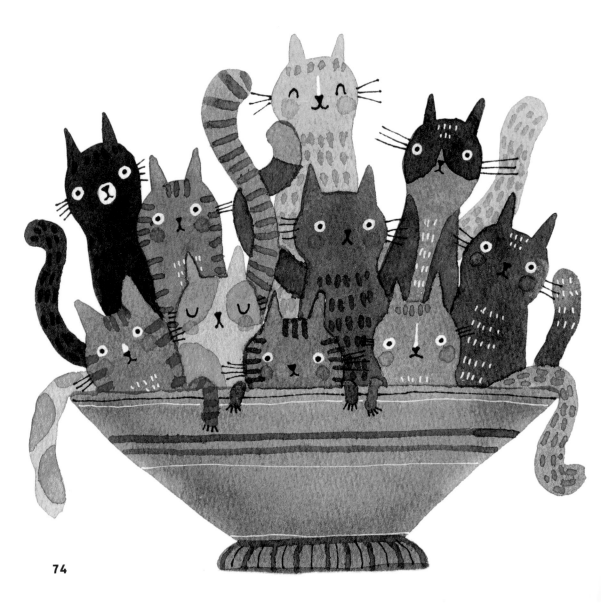

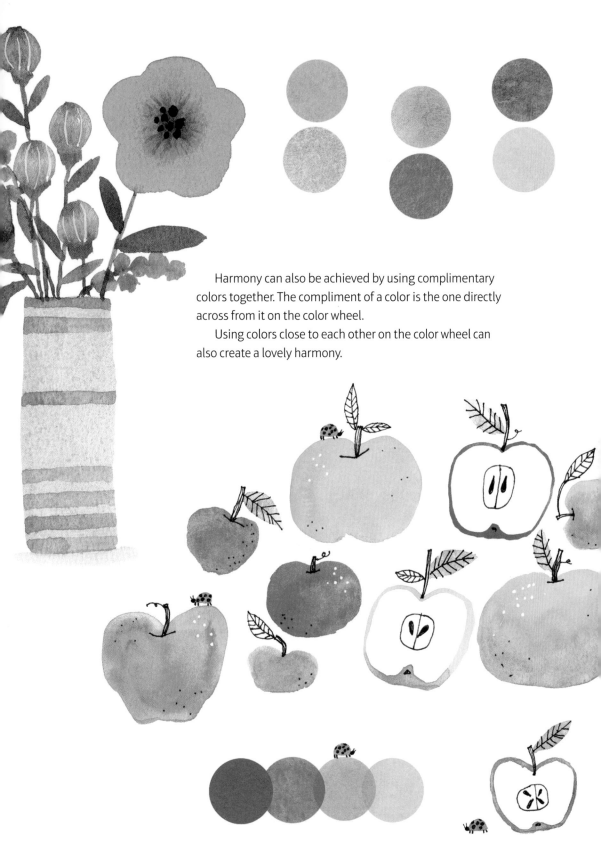

Harmony can also be achieved by using complimentary colors together. The compliment of a color is the one directly across from it on the color wheel.

Using colors close to each other on the color wheel can also create a lovely harmony.

Fill the brush

It is good to establish a habit of using lots of water and lots of paint. Let go of those stingy thoughts or fears of using too many materials. It is easier to pick up extra water and paint than it is to keep going back to the palette to refill.

Background wash

When creating a background wash with watercolor, it is important
to stay present and keep the edge you are working on active (wet)
while other parts of the painting start to dry. This brings you into full
engagement as you move the watercolor over the paper. Once the paint
has dried it isn't possible to go back in and still make the wash seamless.
Remember you can always start again or enjoy the variation left by
partial drying and rewetting. At the very least you have created
some new colored paper to cut up and use for collage!

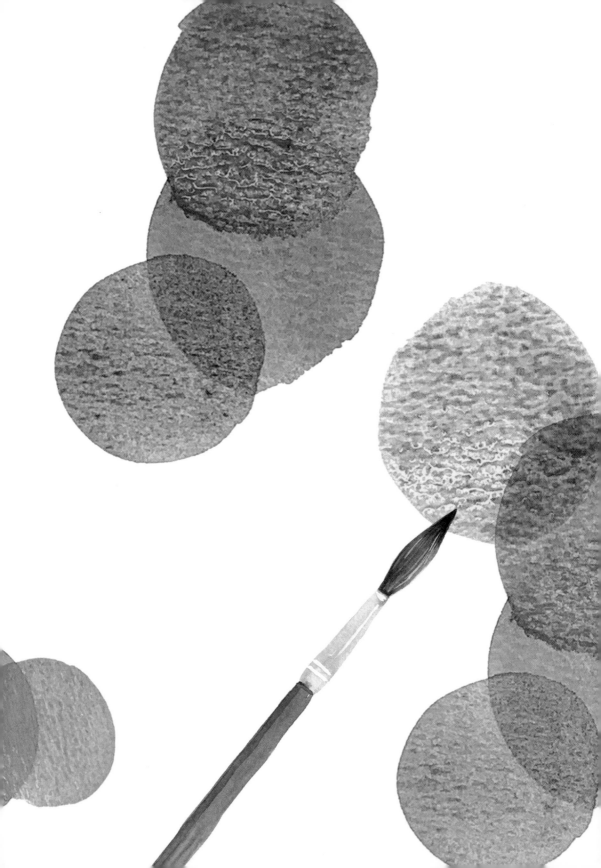

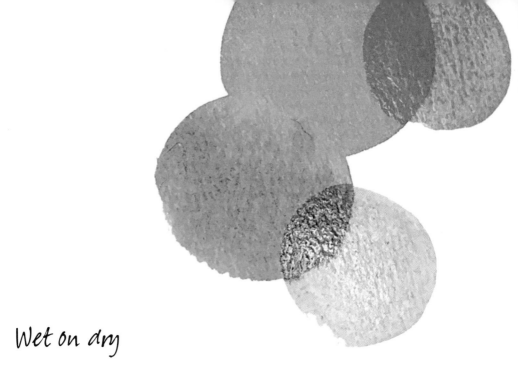

Wet on dry

Once a watercolor painting has dried, you can return to it and add more paint. Even adding the exact same color mix over the top of the dry paint will show up as a darker color because there will be twice as much pigment in the overlapped area. This helps to create depth in a painting. Whether you are adding texture, shadows or other details, more paint can really make it sing.

Wet on wet

With this technique you are working a new brush load of paint into an existing brush stroke that is still wet. This blends colors in very interesting ways and can make for happy surprises. As with any watercolor painting technique, working wet on wet can cause puddles to form, which often leave a dark rim as they dry.
To prevent the paint from settling on the edges of the puddle, a dry, splayed brush can be used to pick up excess water.

Paint value and color intensity

→ Values (the dark and light in a painting) are an important way to direct attention.

→ Hues (how vibrant or dull a color is) can also achieve this affect.

Where dark and light come together there is a point of intensity that often catches the attention of the viewer. Likewise, the most vivid color in a work, where the rest of the color is more grayed down, can capture the viewer's attention. Both of these methods are a wonderful way to guide a viewer to what is most important in a painting.

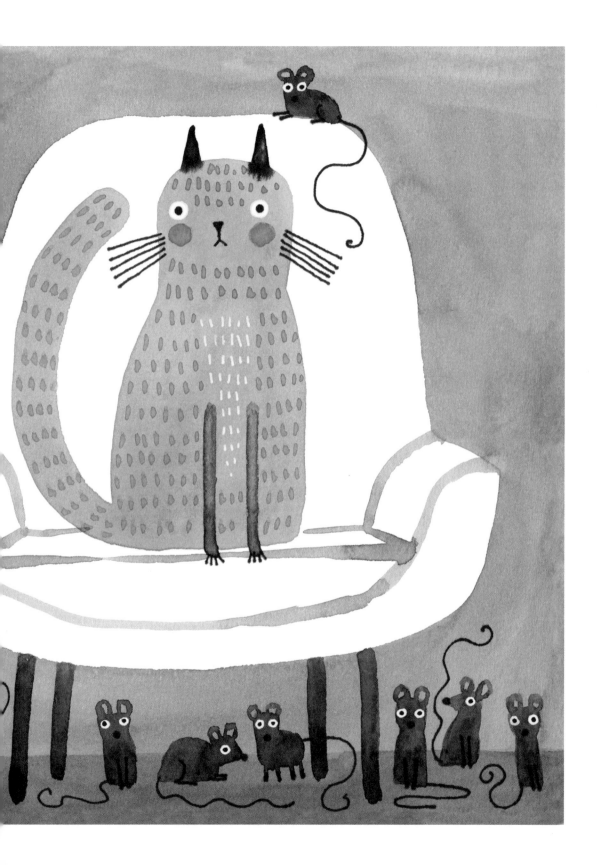

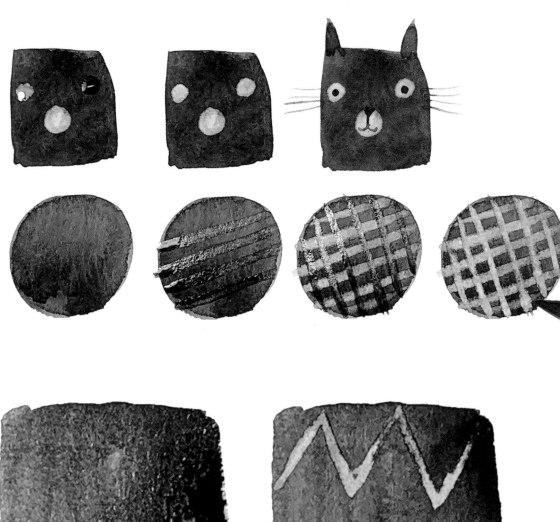

Lifting paint from the paper

Once we have put down a color, we may want to lighten a spot.
Depending on the color and paper used, it is possible to wet an area
and pick up some of the pigment with a clean tissue. I enjoy using this
approach when I have painted a dark animal like a black cat. I will paint
a water spot for the muzzle area then pick the pigment up with a tissue.
This leaves a light area to add a nose and mouth.

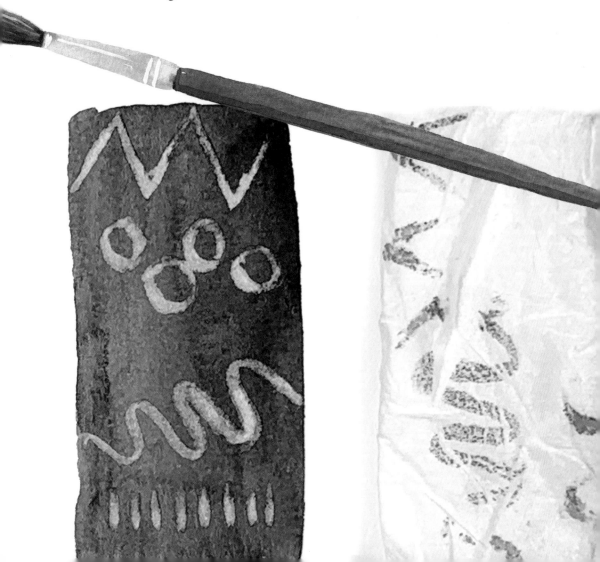

Project 3:

Flower fun

In this project, we are going to paint some flowers.
We will be using both wet on wet, and
wet on dry techniques.

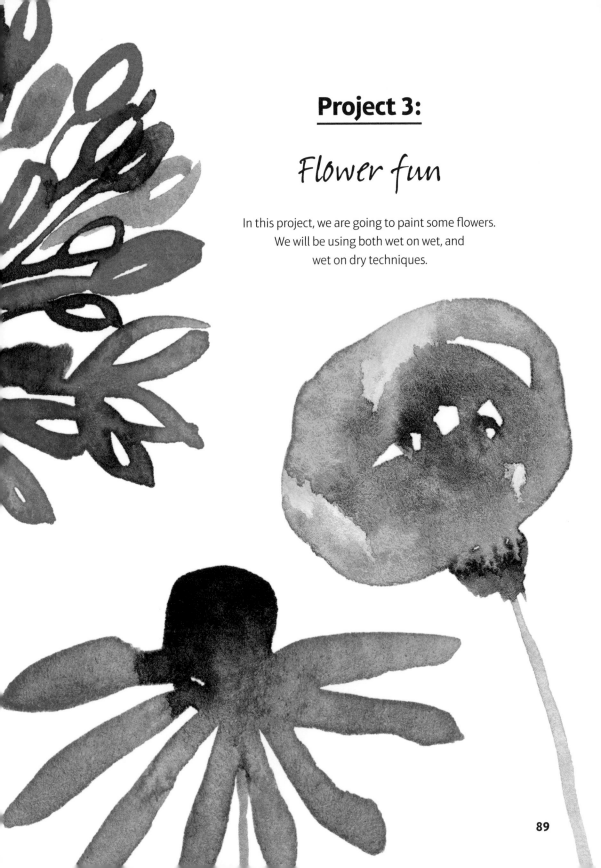

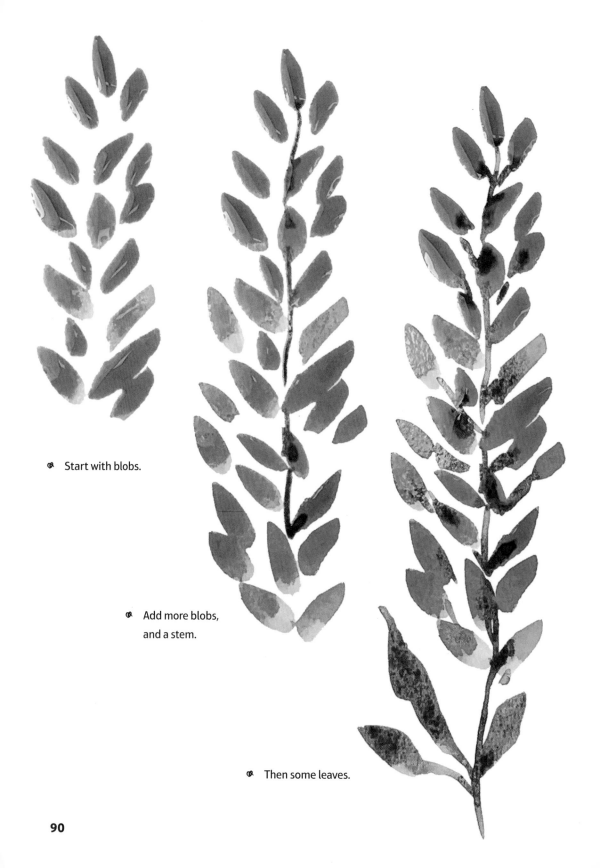

⚘ Start with blobs.

⚘ Add more blobs,
and a stem.

⚘ Then some leaves.

90

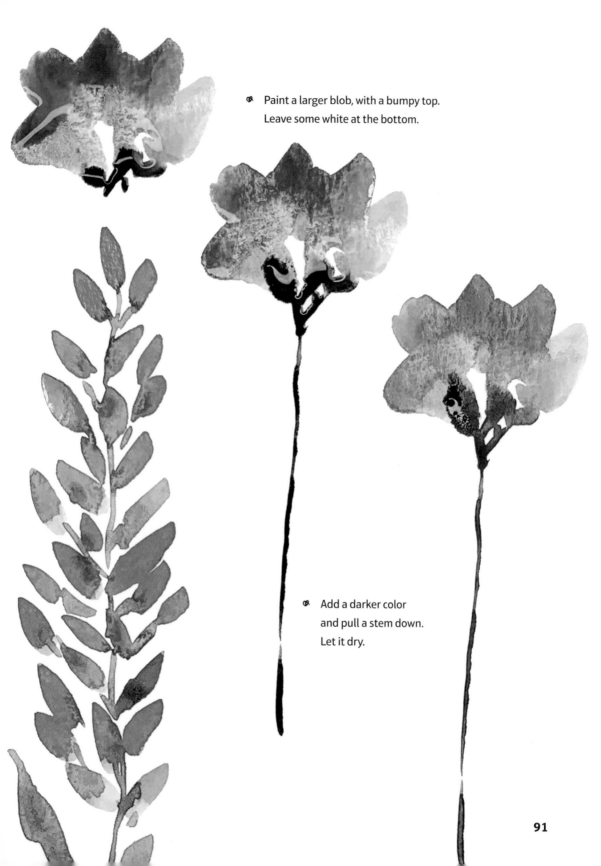

Paint a larger blob, with a bumpy top. Leave some white at the bottom.

Add a darker color and pull a stem down. Let it dry.

Start with blob shapes again.
Put a darker dab of the
same color in the middle.
Pull a stem from the bottom.

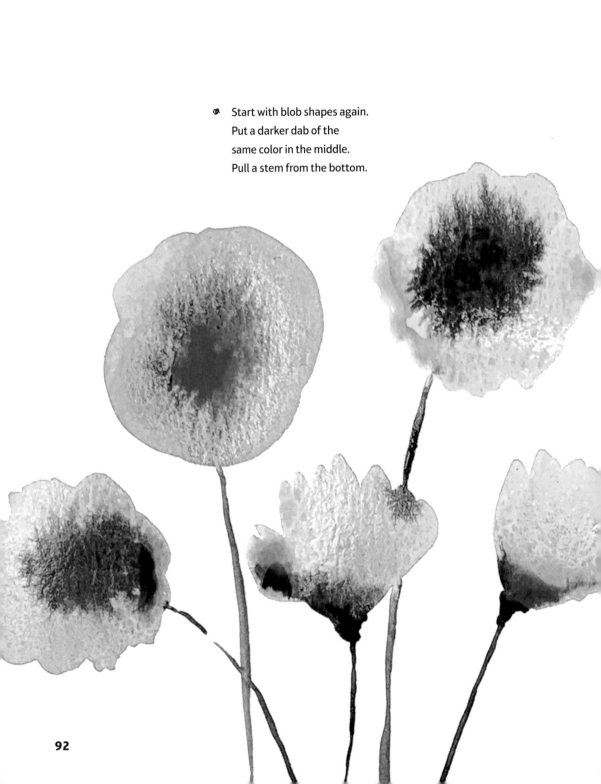

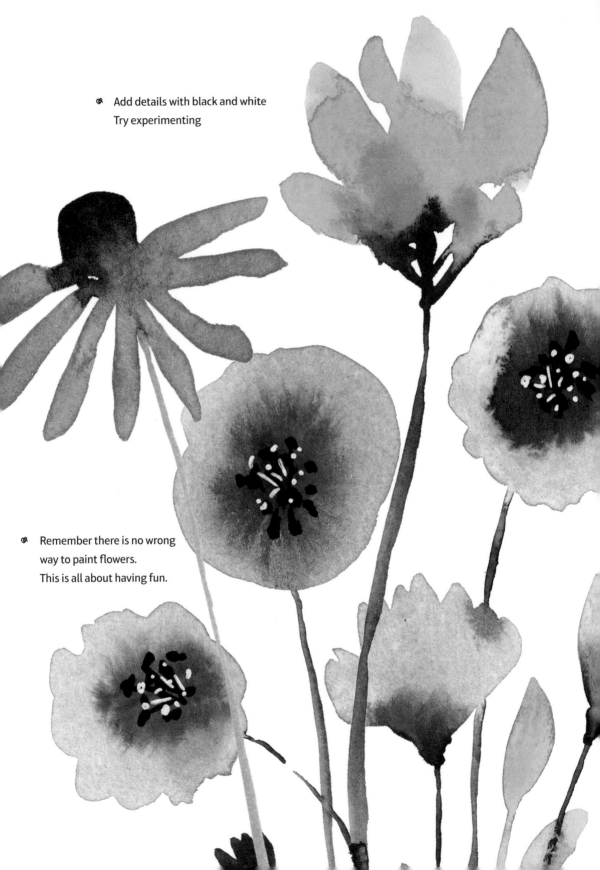

◈ Add details with black and white
 Try experimenting

◈ Remember there is no wrong
 way to paint flowers.
 This is all about having fun.

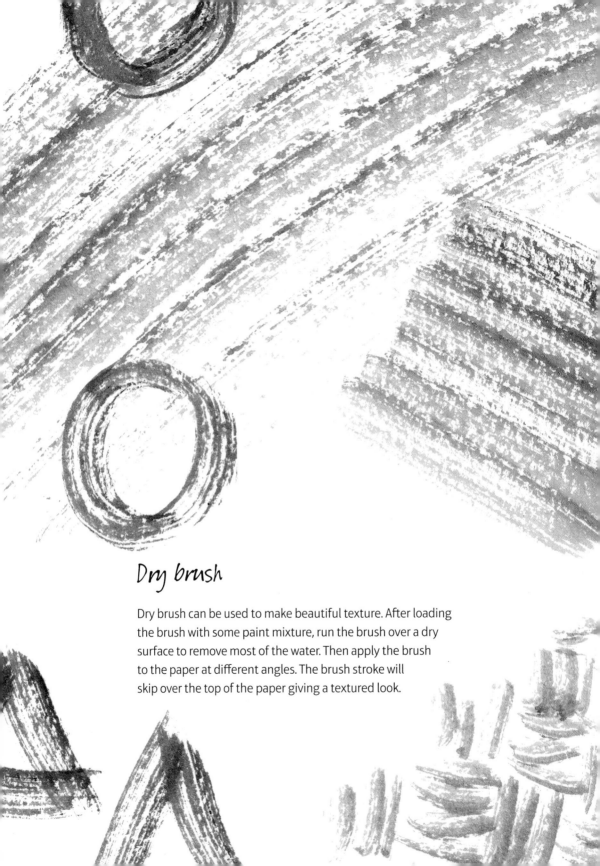

Dry brush

Dry brush can be used to make beautiful texture. After loading the brush with some paint mixture, run the brush over a dry surface to remove most of the water. Then apply the brush to the paper at different angles. The brush stroke will skip over the top of the paper giving a textured look.

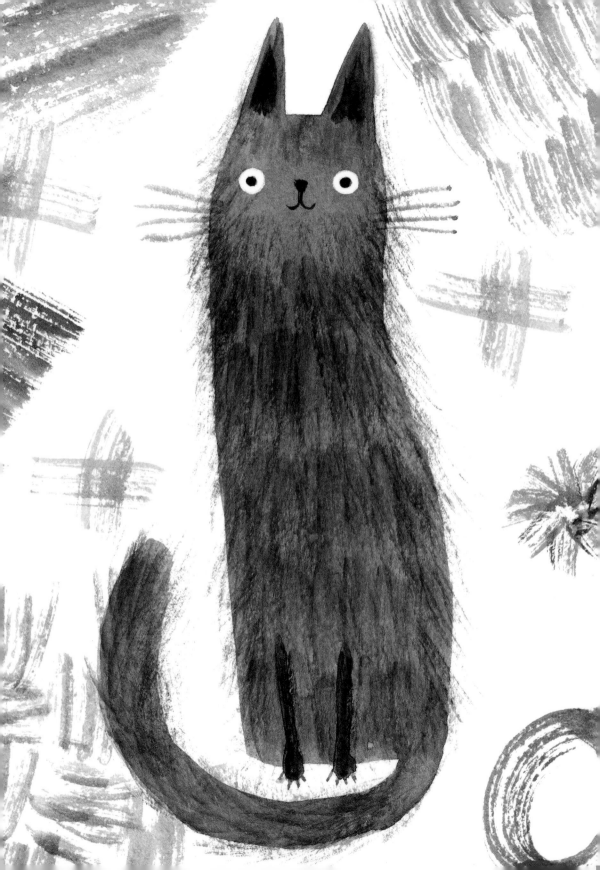

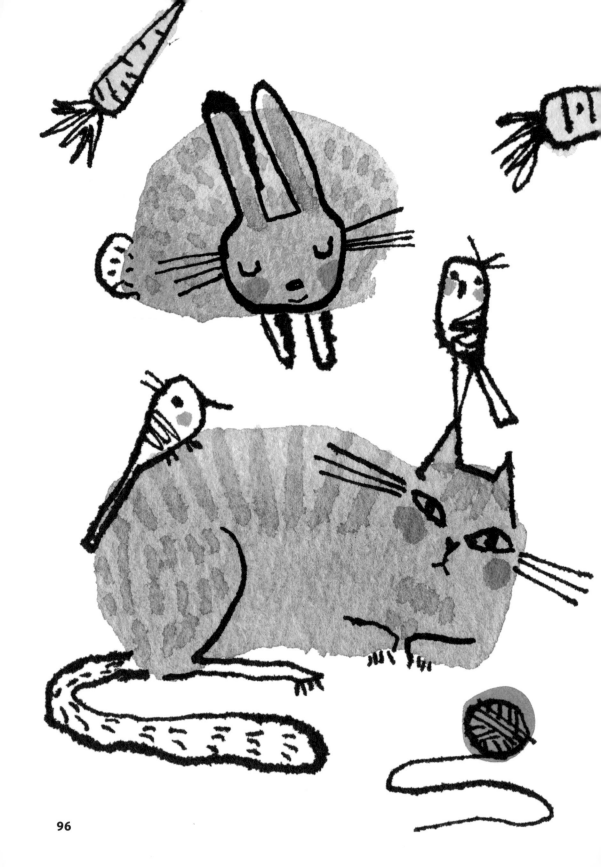

Shapes

I love working with shapes when I create paintings. Starting with a shape, whether it is an undefined blob of color or something recognizable, is a fun way to create. It is amazing how much can be seen in the shape of the object before details are added. It's also fun to let the shape of the object lead you into what it might be. This is a playful way to stay loose and open when painting (as seen in the "From blobs to birds" project). The same can also be achieved with bunnies or cats, even if you don't know how to paint them. Adding ears, tails, and whiskers is all that is needed!

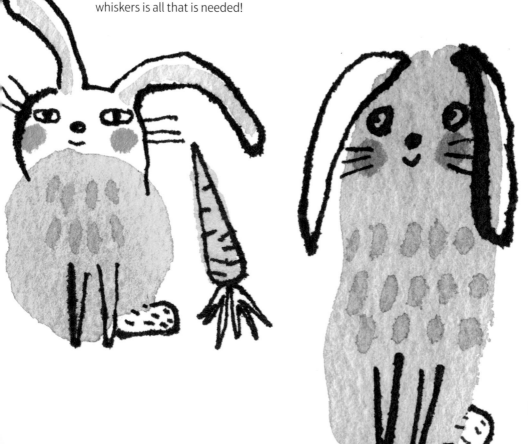

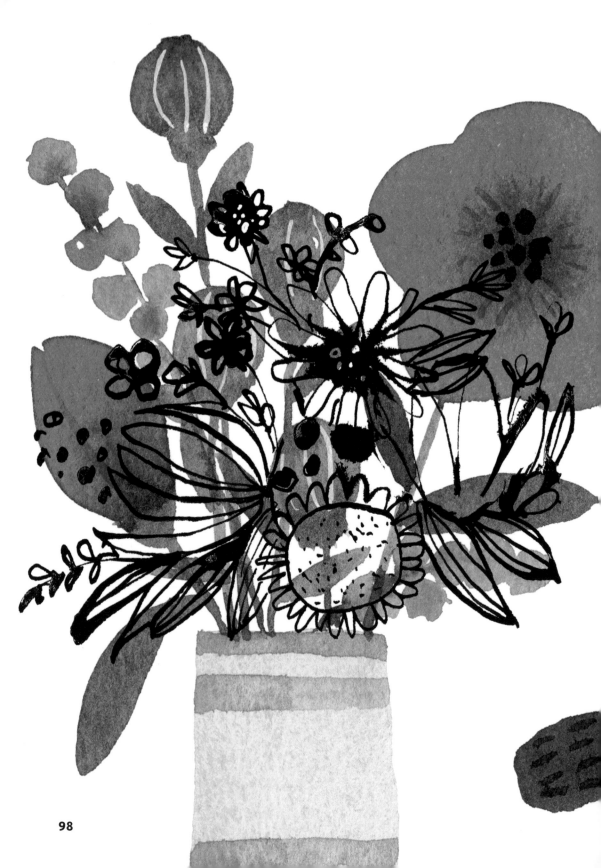

Lines

Using lines to add detail such as eyes, mouth, leaf details, stems, and fur can define the work and give it personality. I personally prefer not to outline my work. I enjoy letting the shape of the object define the edge. If something in the painting is losing the edge because the value or color of the objects is close together, a subtle line or some shading can be used to differentiate the objects from each other. Surrounding objects with lines is another style that many creators enjoy. This gives the work more of a coloring-book look or a cartoon style when used on characters.

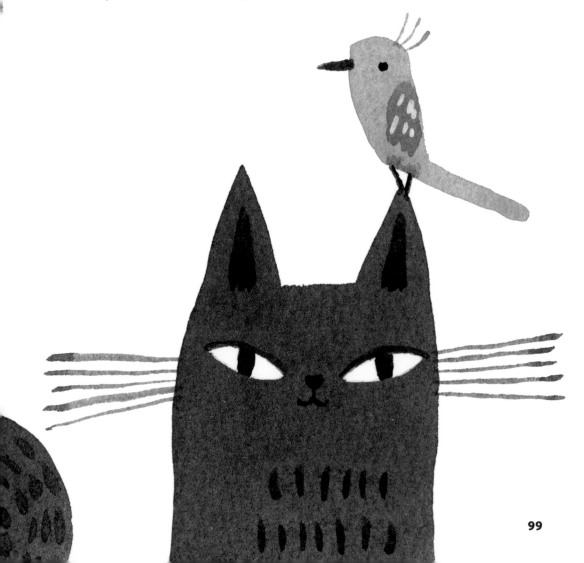

What about design and layout?

It may be helpful to have a bit of design sense, but it isn't necessary in order to enjoy painting. Having the freedom to flow with the paint is a lovely way to explore creativity. I like to give my art a sense of balance. Of course, there is nothing wrong with a painting being imbalanced. An imbalanced painting can evoke a feeling all its own. I'm not much of a strategic planner when it comes to design. I've learned a lot about design over the years but it is more of an intuitive thing at this point. As you continue with your creative journey, you will start to develop a sense of design, not unlike how your style emerged. In addition, there are many great books out there on design if you are interested in learning more.

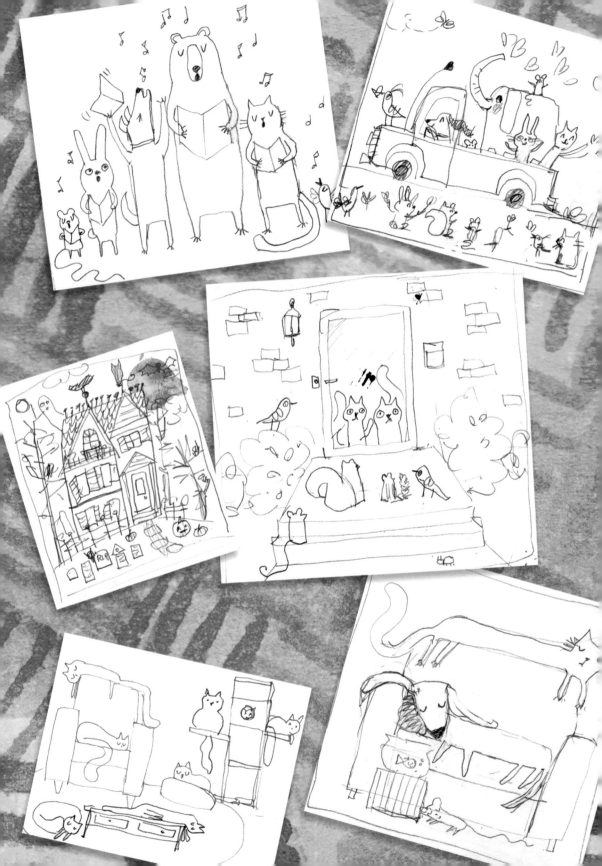

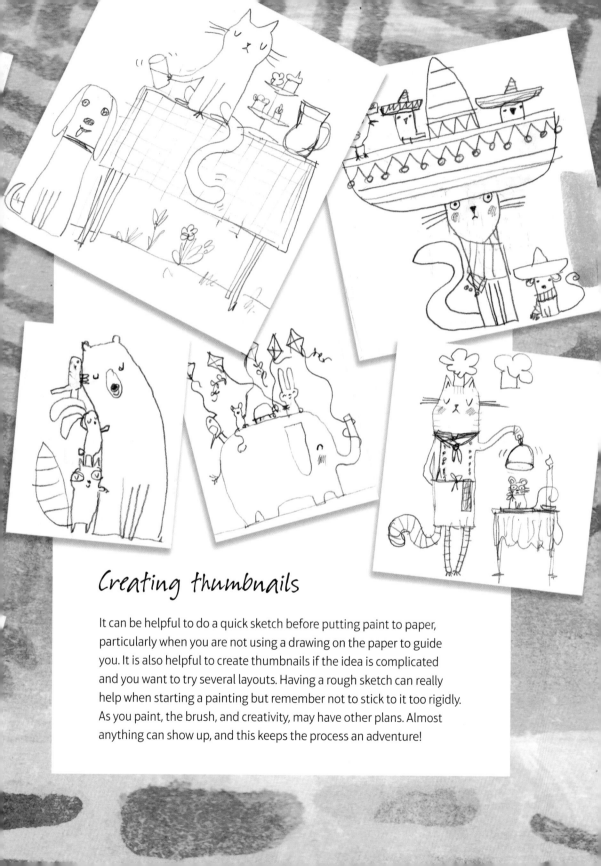

Creating thumbnails

It can be helpful to do a quick sketch before putting paint to paper, particularly when you are not using a drawing on the paper to guide you. It is also helpful to create thumbnails if the idea is complicated and you want to try several layouts. Having a rough sketch can really help when starting a painting but remember not to stick to it too rigidly. As you paint, the brush, and creativity, may have other plans. Almost anything can show up, and this keeps the process an adventure!

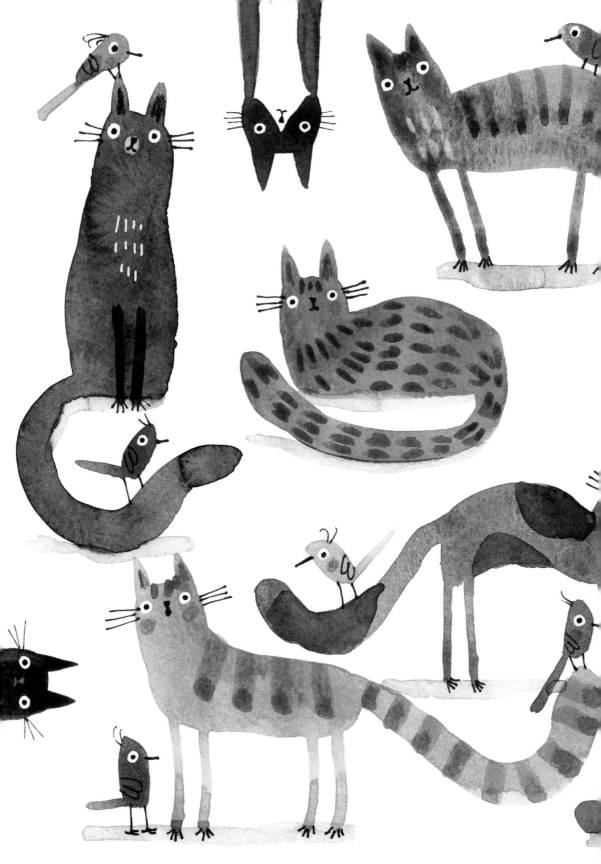

Project 4:

From can't paint to cat painting

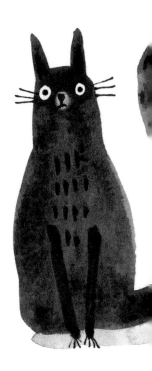

You might be someone who thinks they can't paint. Perhaps you are new to painting or your inner critic thinks you don't have the talent. In this project, all you need to do is to loosely follow these simple and fun steps.

Anyone can paint a cat. Follow along while staying open and free, and see what cat shape you come up with. The possibilities are endless!

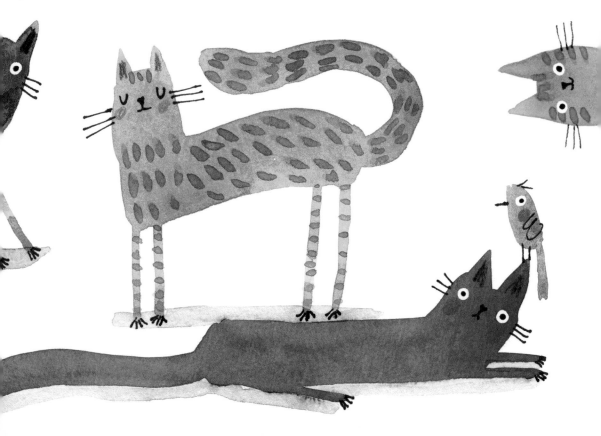

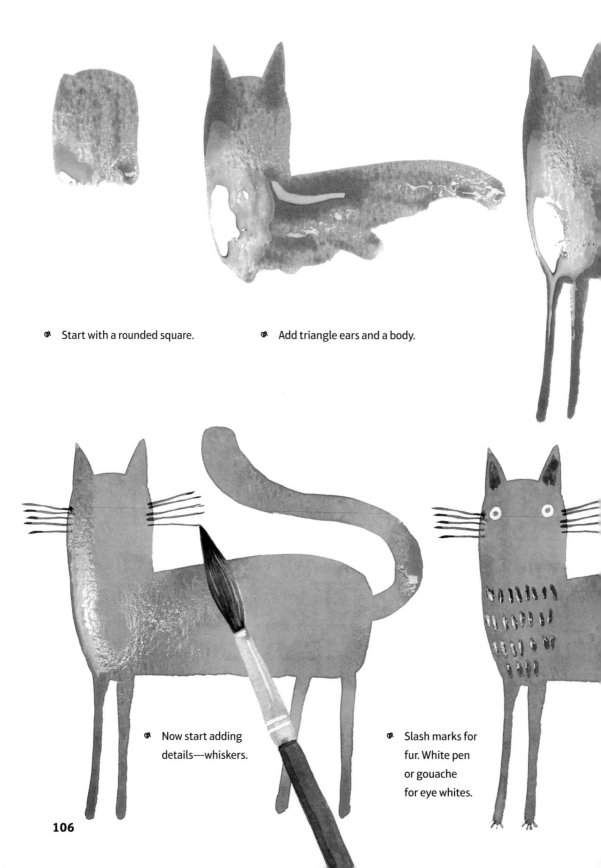

- Start with a rounded square.

- Add triangle ears and a body.

- Now start adding details—whiskers.

- Slash marks for fur. White pen or gouache for eye whites.

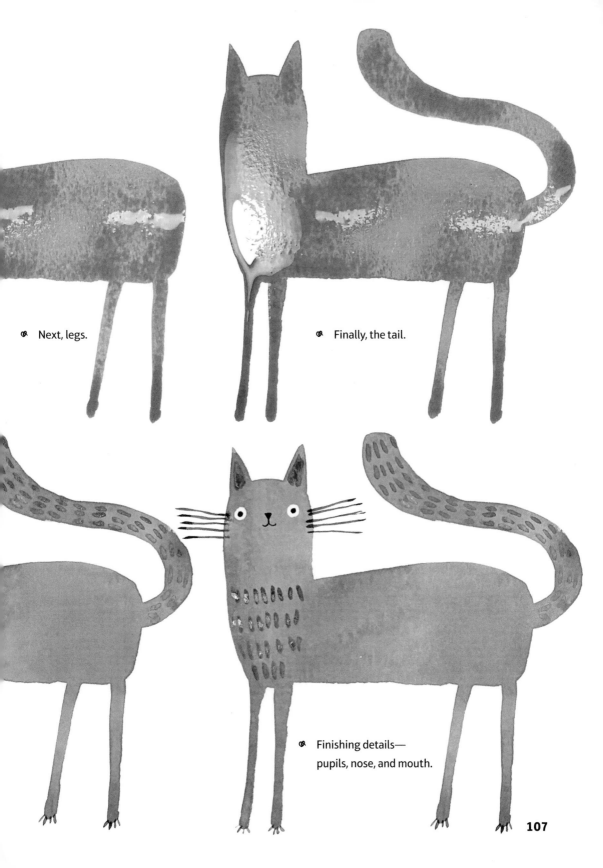

Next, legs.

Finally, the tail.

Finishing details—
pupils, nose, and mouth.

107

🐾 Start with a more round shape.

🐾 Add the body and ears, then a tail.

🐾 With a wet brush, make a circle between and slightly below the eyes. Then dab it with a tissue.

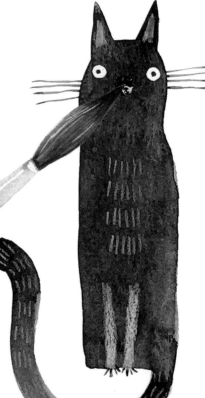

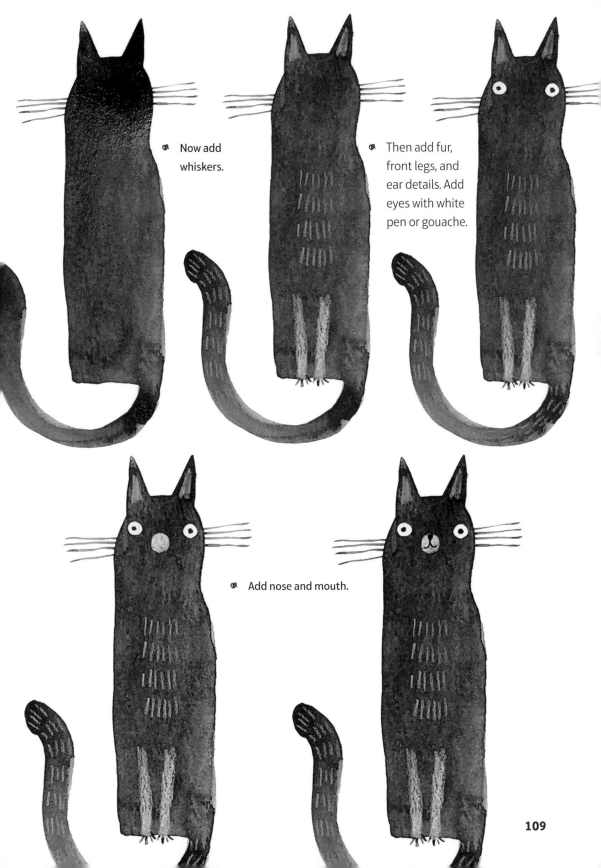

Now add whiskers.

Then add fur, front legs, and ear details. Add eyes with white pen or gouache.

Add nose and mouth.

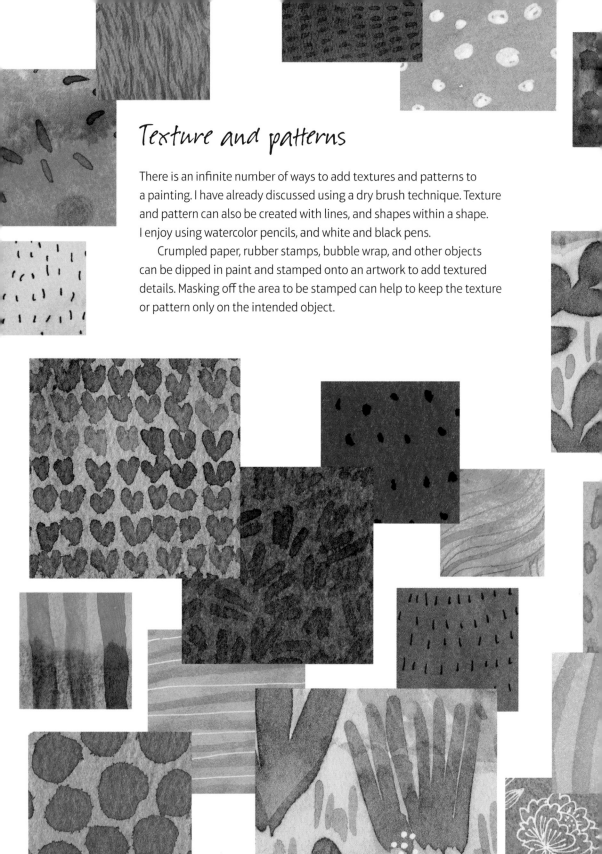

Texture and patterns

There is an infinite number of ways to add textures and patterns to a painting. I have already discussed using a dry brush technique. Texture and pattern can also be created with lines, and shapes within a shape. I enjoy using watercolor pencils, and white and black pens.

Crumpled paper, rubber stamps, bubble wrap, and other objects can be dipped in paint and stamped onto an artwork to add textured details. Masking off the area to be stamped can help to keep the texture or pattern only on the intended object.

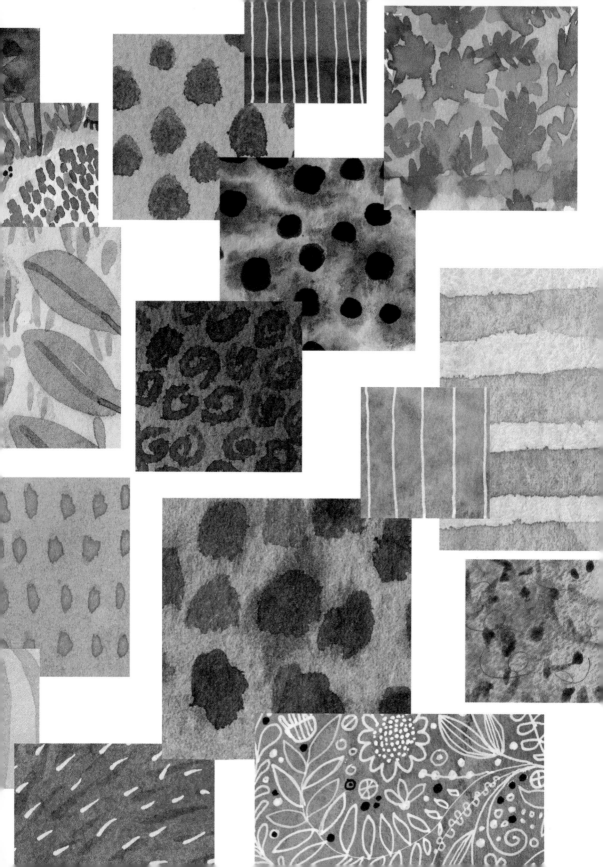

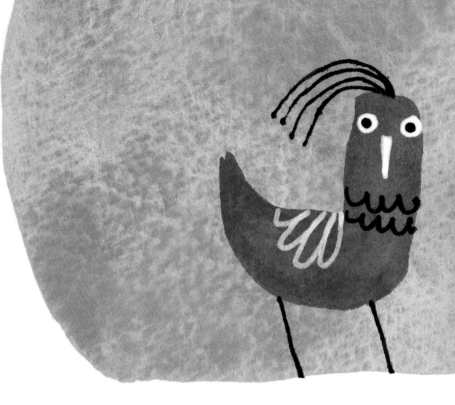

Painting around a shape

Painting around the shape you want to create is often called negative space painting. Most of the time this is achieved by first making a light pencil outline of the object and then painting around the drawing to leave the object white. However, I find it fun to paint freestyle, starting at the top and working my way down the piece, leaving the paper white where the object might be. This works best with shapes you are familiar with. I prefer this approach because I don't know exactly how that shape will turn out since I have not drawn it first. This provides an element of surprise and freshness in the work.

All shapes are beautiful in their own right. Keep focusing on your art and letting those inner-critic thoughts pass by unattended.

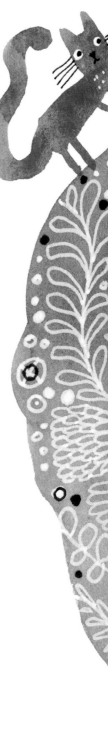

Watercolor additions

Beyond watercolor there are many tools to use to add interest to a painting.

I love using white in my watercolor paintings. There are several different types of white pen available to use for details and eye whites. My favorites right now are Posca acrylic pens, usually with the finest tip available. Because Posca pens are acrylic-based, they can have a bit of a sheen to them when covering a larger area. I will often cover over the acrylic marker spots with white gouache, an opaque watercolor, to reduce any shine that might occur. This makes the white area easier to draw on as well.

White gouache can be used on its own but it may take several coats to produce an opaque white finish. White paint can also be applied with a dip pen or brush.

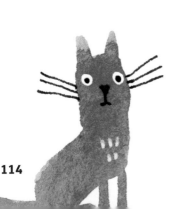

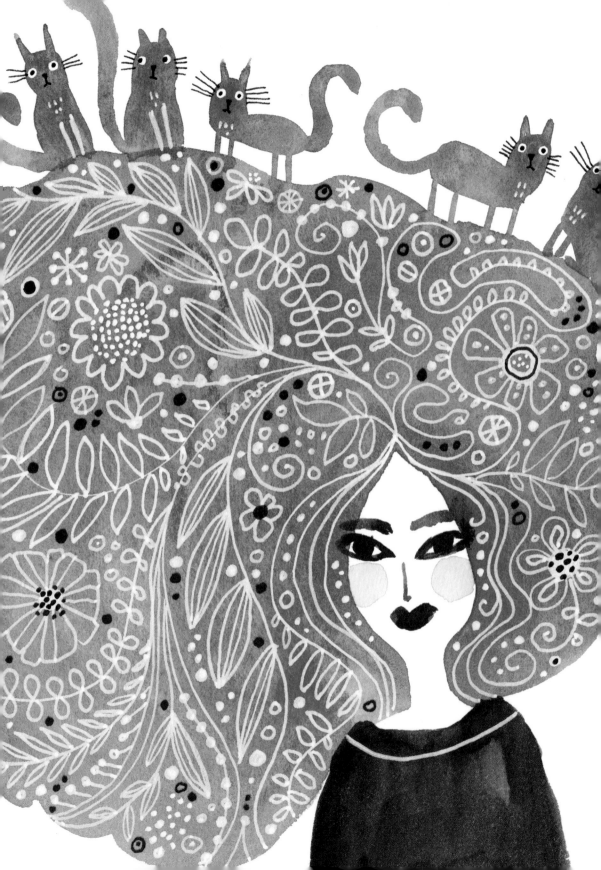

India ink

I love adding India-ink details and drawings to my watercolor paintings. This can be done while the painting is still wet, which yields fun and surprising results. Since controlling the results is not easy (if not impossible), it keeps the painting process fresh and exciting.

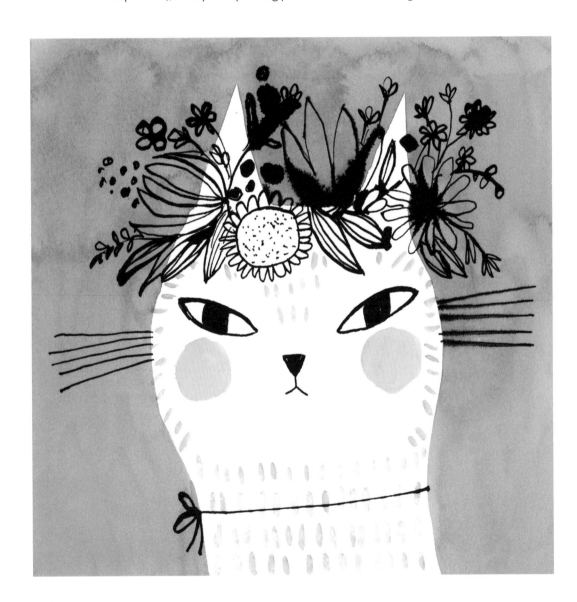

Adding black lines

I have an assortment of sizes of black line pens. I like to use permanent-ink pens because I may want to add more watercolor after the line is put down. Using nonpermanent-ink pens can smear and run into the watercolor around it when applying more paint or water.

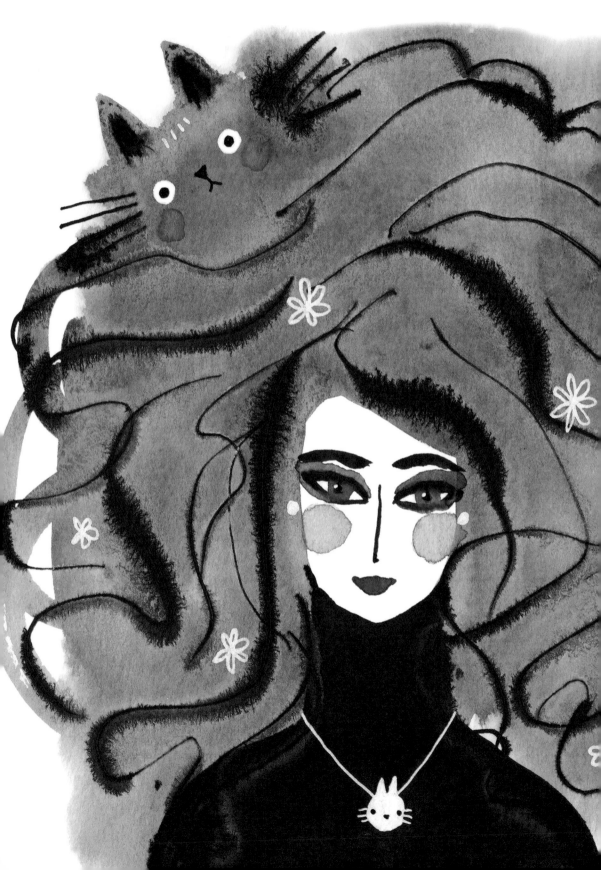

Project 5:

It's all in the hair

A cat on the head has infinite possibilities! Cats can bend
into any shape; they flow like hair. In this project, we play with
watercolor portraits that include cats, India ink, and white
pen details. Also known on Instagram as
#catonheadwednesday!

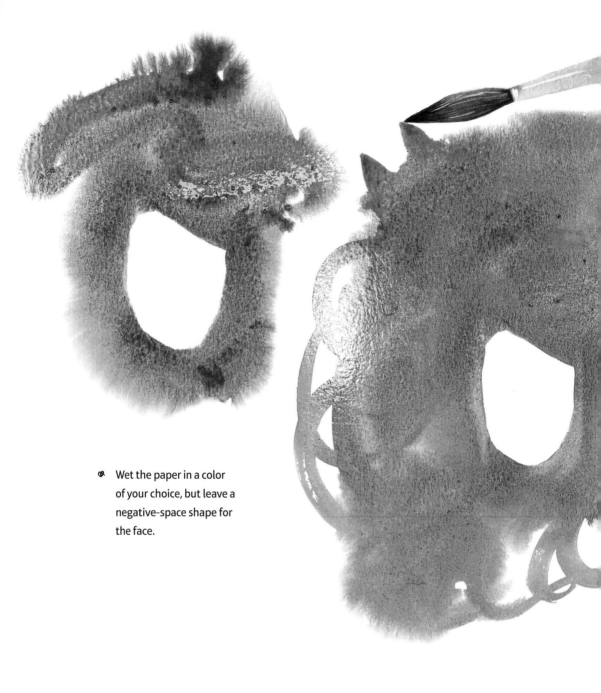

Wet the paper in a color of your choice, but leave a negative-space shape for the face.

Take the paint outward, being sure to add a couple of cat ears.

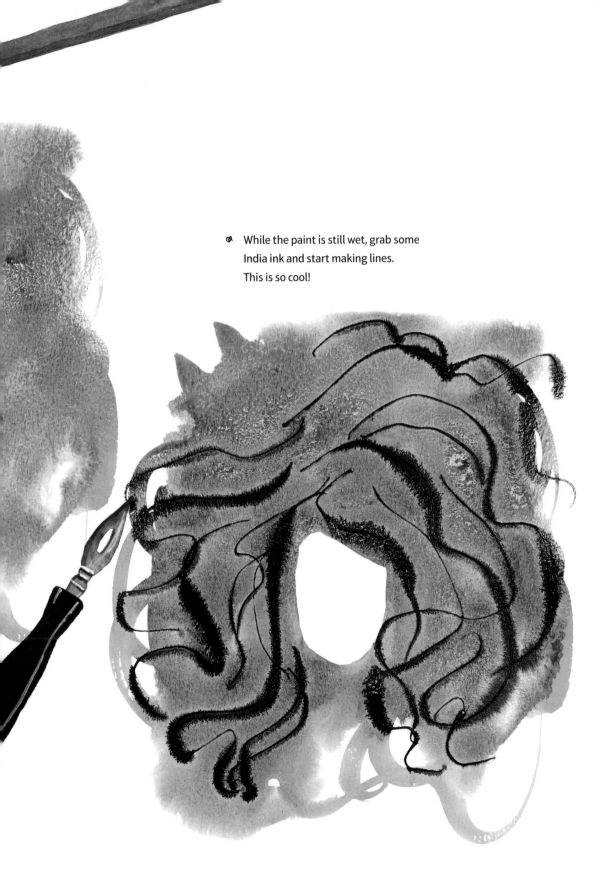

While the paint is still wet, grab some India ink and start making lines. This is so cool!

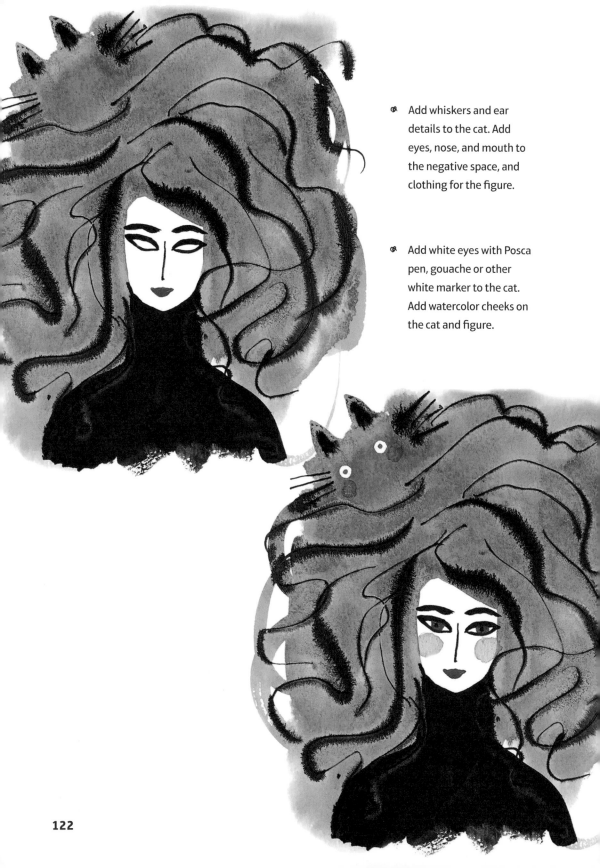

- Add whiskers and ear details to the cat. Add eyes, nose, and mouth to the negative space, and clothing for the figure.

- Add white eyes with Posca pen, gouache or other white marker to the cat. Add watercolor cheeks on the cat and figure.

122

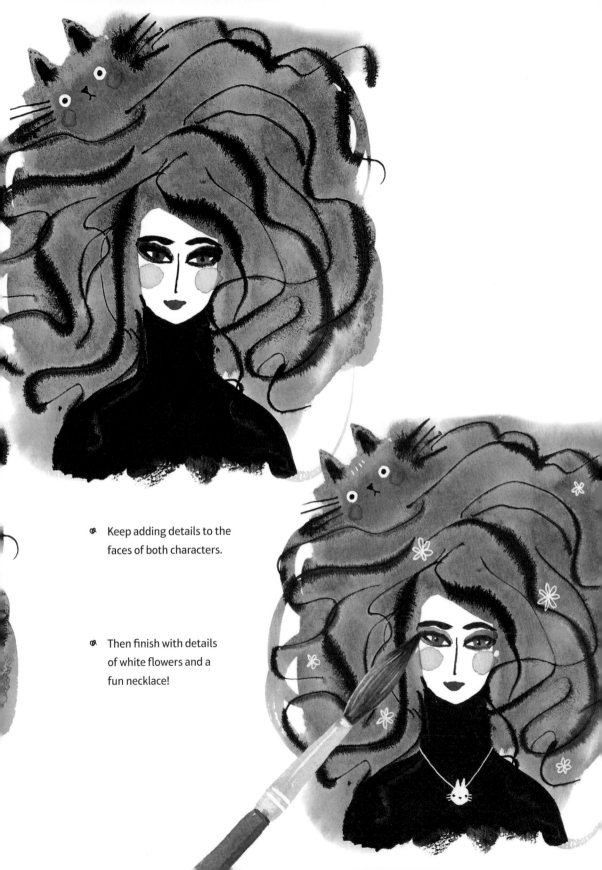

❀ Keep adding details to the faces of both characters.

❀ Then finish with details of white flowers and a fun necklace!

Pencils

Using watercolor pencils is a fun way to add texture and definition to a painting. I love using them for cheeks on animals. As mentioned before, using them while the paper is wet is so satisfying because of the smooth buttery feel of the pencil. Often I will draw over a background color when it is still wet to add texture. These pencil marks can also be painted on by wetting the pencil first. I usually don't use the pencils for this purpose because I prefer using a brush and watercolor to achieve what I am looking for, but experimenting with this technique can be loads of fun.

Finishing touches

All of these additions to the watercolor bring the final painting together. Sometimes adding whiskers and cheeks can be just the thing the painting needs to feel complete. Adding extra spots of color and details, maybe a bird, flower or mouse, can bring the painting together as well, and tell a story!

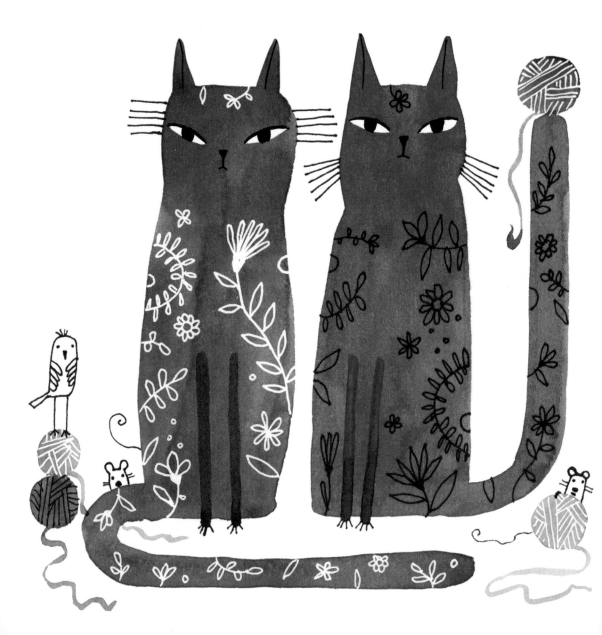

Remember, the painting does not have to come together for it to be totally worth exploring. It can be very satisfying to cover a page with numerous objects or overlapping paint strokes, textures, and patterns. All of these ways of creating give you a beautiful connection to creativity.

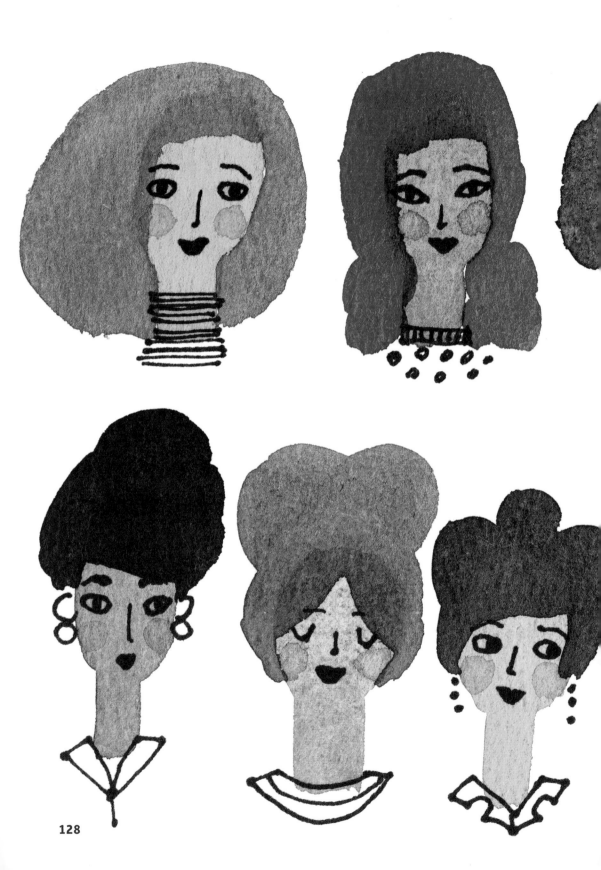

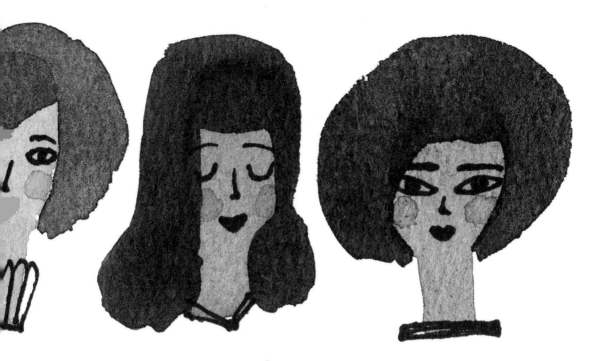

Project 6:

Characters and faces

It is so fun to create personalities starting with a blob or a lightbulb-like shape. Just paint another blob for the hair then add features.

Play around with various features and details on your blob heads. Treating each one differently will give them all different personalities!

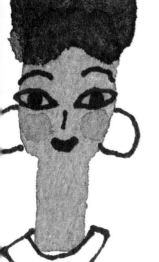

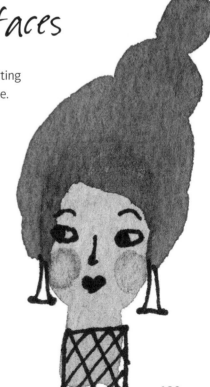

Start with a round, oval or rounded square shape.

Bring in some new colors or use the same colors on different heads to mix it up for the hair.

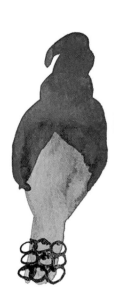

❀ Add necks to the bottom.

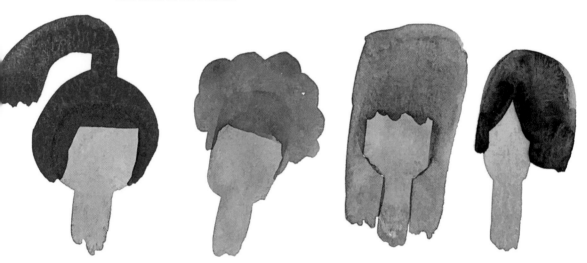

❀ Make sure to vary your hair shapes like you did the head shapes.
 Next, use ink or contrasting color to add collars to the necks.

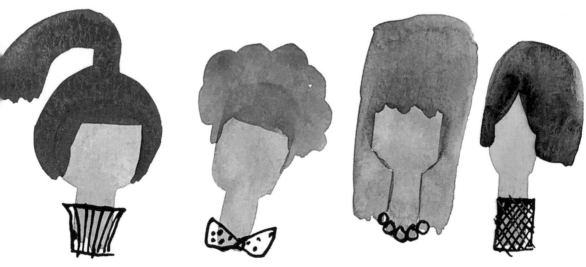

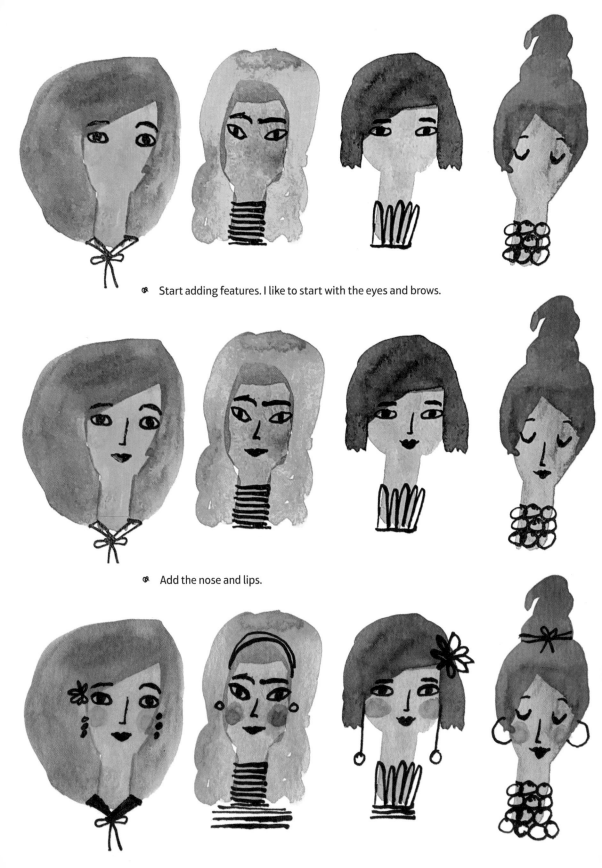

Start adding features. I like to start with the eyes and brows.

Add the nose and lips.

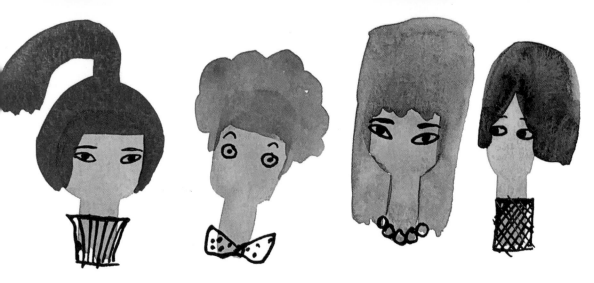

 ❧ Make sure to make lots of different eye shapes to keep it interesting.

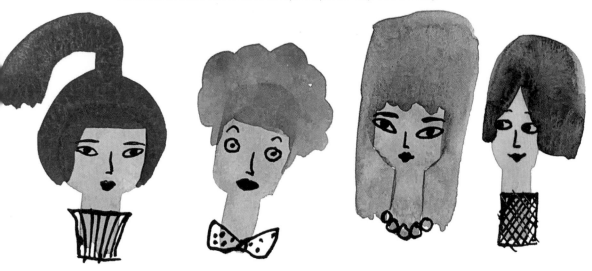

 ❧ Finish off with earrings, hair bobbles, clothing, and cheeks—keep it fun!

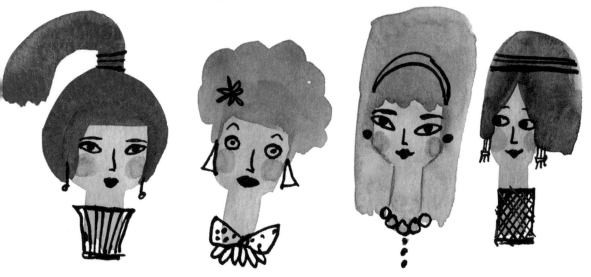

Things to bear in mind with characters

When drawing characters, interaction between them (eye contact, facial expressions, and actions) can help to evoke emotion in the scene. This is a fun way to tell a story with your art. You can also create beauty or patterns that may not have a story. It all works!

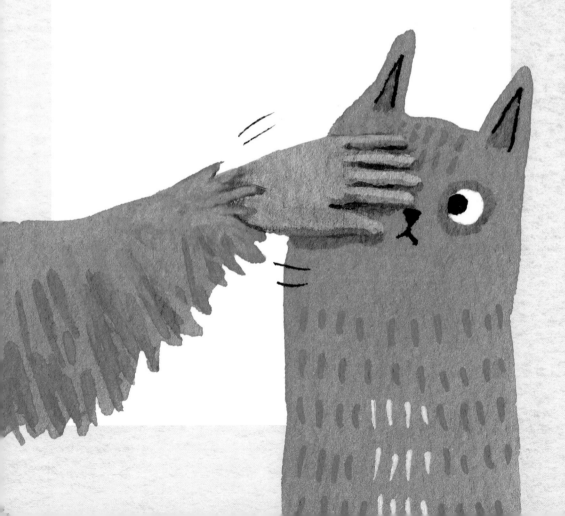

6

When Is It Done?

Keep an open mind

There comes a moment when you wonder if you have finished. This is a moment full of possibilities. If you have been painting for a while you may have gained a natural sense of when something is complete. This often comes from years of trial and "error."

For most of us, the inner critic may chime in at this moment. There can be a fear of ruining what we have accomplished so far. Even with lots of experience, overworking a painting still happens. However, there are some things that can be done to help us get a sense of whether to stop or keep going. Keeping an open mind and creating art for the fun of it helps us to weather these times and appreciate the creative expression no matter how it turns out. For most of us, knowing when a paintingis done is something we learn as we paint.

Remember that not knowing when your art is finished is a natural part of learning to paint. When you think it has to be just right, once again, the inner critic has joined you. Remember this critic is trying to protect you and keep you safe. It means well but it is misinformed. Let it move through and focus back on what you are creating.

Maybe one more step?

If you are uncertain, or don't feel a sense of when to stop and you don't like how it is going, sometimes there is another step or two that can bring the painting back to life. If not, grab another piece of paper and play some more.

Step away and then come back

Another thing you can try is to step away and come back to the painting with fresh eyes. It can be quite startling and exciting to see something anew. You may see exactly what is needed or find the work is indeed done.

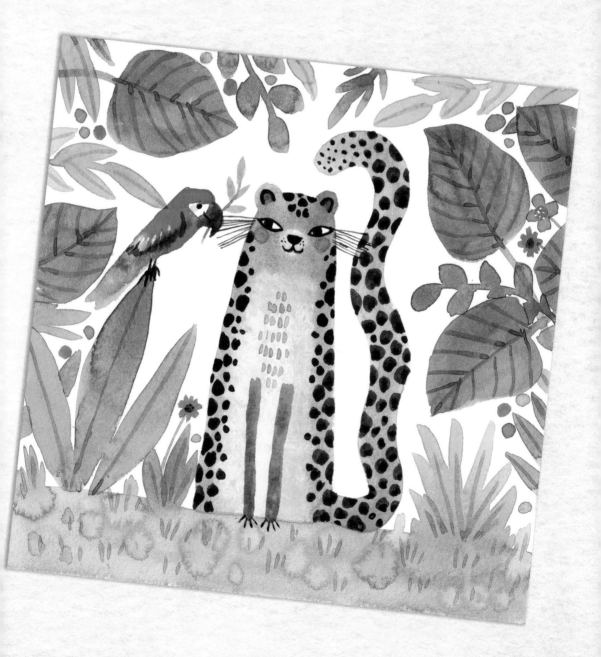

Getting a different view

Try turning the painting upside down, looking at it in a mirror or through a camera for a new point of view. Anything to get a fresh perspective can help to give you a clearer idea of what is still needed, or show you the painting is complete.

Start something new

No matter how a painting turns out, there is always something new arriving where you are now. Whether you start a new work, cook dinner, go for a walk, or take a nap, it is a new moment, and this is also creativity unfolding.

Learning to let go

Whether you know whether a painting is finished or not, it is important to remember to be present for the process by continuing to let go of the results. Some people have a sense of when a painting is done sooner than others do. I have been a slow learner in this area, either stopping before I know a painting is done, or overdoing it. Either way, I see it as a learning experience: an opportunity to paint some more or to start a new painting. Each time we overdo a painting, which happens to all of us, it helps us to hone our ability to determine naturally when something's done.

So deciding whether your work is done, or whether or not you have picked the right time to stop, is not as important as the act of creating. The most powerful way to leave fear behind is by not paying attention to the inner-critic thoughts that chirp in your ear, and by focusing back on the paper, paint, and brush in your hand moving across the paper.

Remember: an overdone painting can always become a wonderful color or pattern to cut up for mixed-media collages!

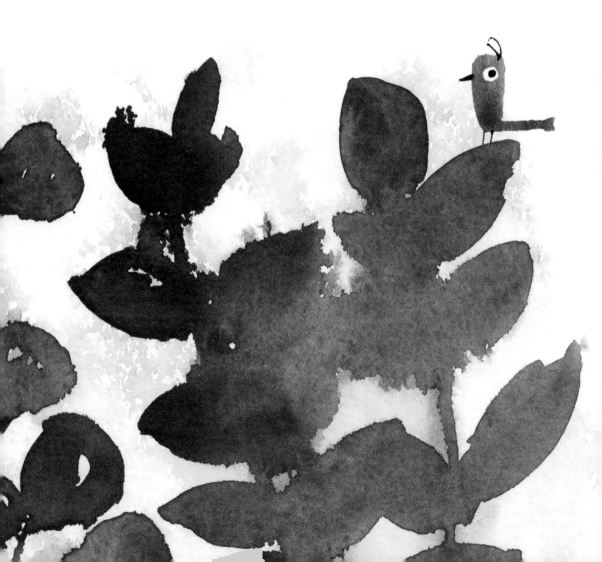

Style

This book is not about finding your art style, but as you create over a period of time, you will start to see the uniqueness in how your hand moves and how things come together. It is always good to pay attention to this. Also, ask yourself these questions:

→ What types of art do you like?
→ What do you find inspiring?

These things point to your unique aesthetic and give you clues to what your creativity might look like as you move forward.

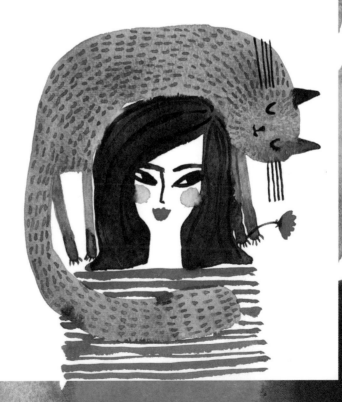

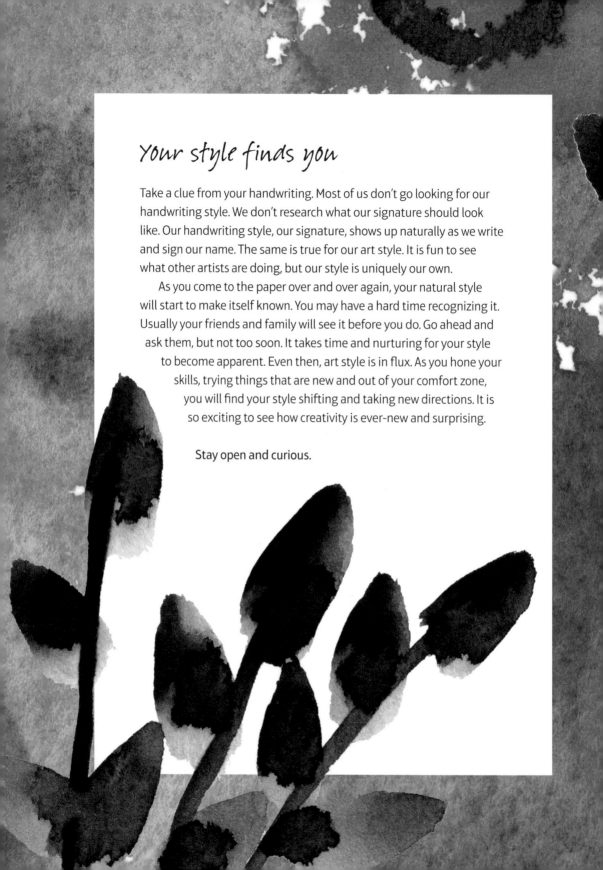

Your style finds you

Take a clue from your handwriting. Most of us don't go looking for our handwriting style. We don't research what our signature should look like. Our handwriting style, our signature, shows up naturally as we write and sign our name. The same is true for our art style. It is fun to see what other artists are doing, but our style is uniquely our own.

As you come to the paper over and over again, your natural style will start to make itself known. You may have a hard time recognizing it. Usually your friends and family will see it before you do. Go ahead and ask them, but not too soon. It takes time and nurturing for your style to become apparent. Even then, art style is in flux. As you hone your skills, trying things that are new and out of your comfort zone, you will find your style shifting and taking new directions. It is so exciting to see how creativity is ever-new and surprising.

Stay open and curious.

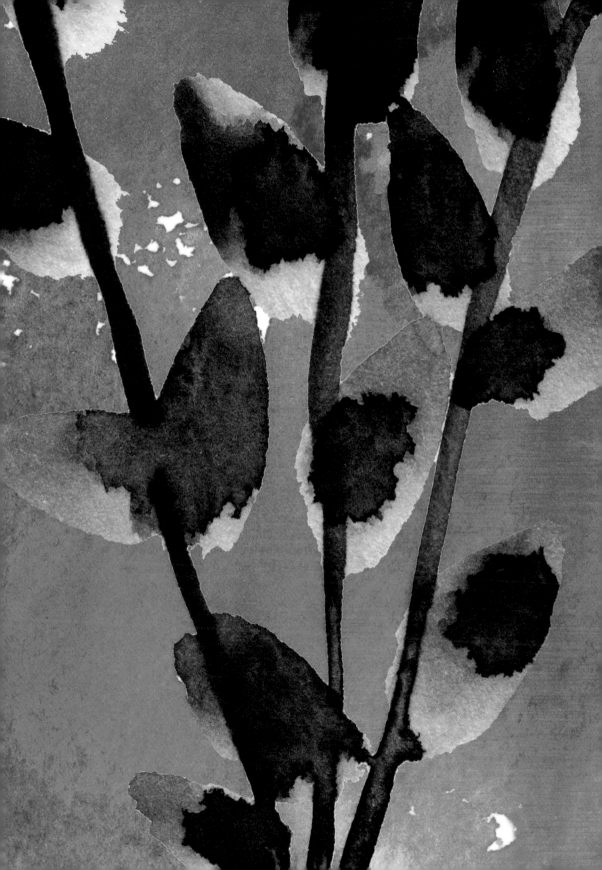

Research

I encourage you to look at a lot of artwork by other artists and illustrators, as well as nature, photography, poetry—whatever speaks to you. While doing, this pay attention to what is jumping out at you, what is moving you forward.

 The purpose of research is not to copy what you see, but to let it inform us about what our aesthetic is, our interests, and our own unique voice. So go ahead and do a lot of research, but pay attention and take the opportunities when you feel inspired to stop and make some art!

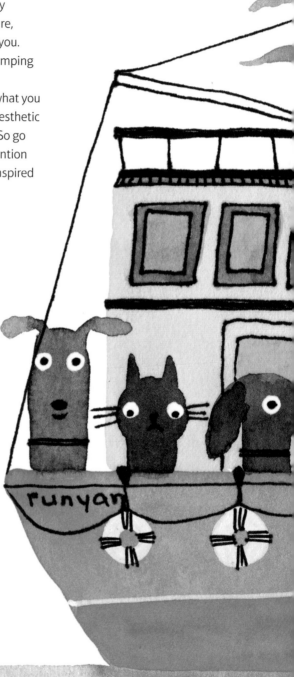

Researching can be very helpful, but it can also be a huge distraction and stop us from moving forward with our creativity. Minutes can turn into hours and, before we know it, we have spent the entire day or week consuming inspiration without expressing any of our own art. I have firsthand experience with this and it is exhausting, leaving no energy to put brush to paper.

Inspiration is a unique moment-by-moment experience. If we don't move when it comes, it will be replaced by the next moment, never to be experienced the same way again. Fortunately, if you miss a moment, there is no need to worry. More inspiration is as close as the next breath in. Just take time to breath out with your art!

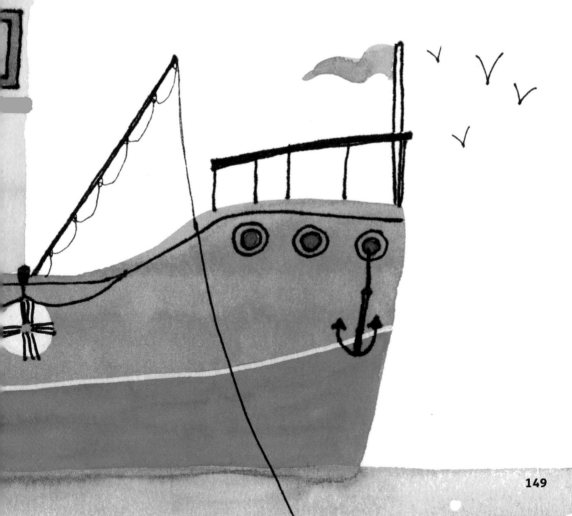

Creating over time

Ultimately, we want to create often over a period of time to see where our art goes. While we remain focused on having fun and enjoying the process, we end up creating more often and before we know it, we start seeing own signature style in our work, not as something static, but as an ever-changing dance between you and the paper.

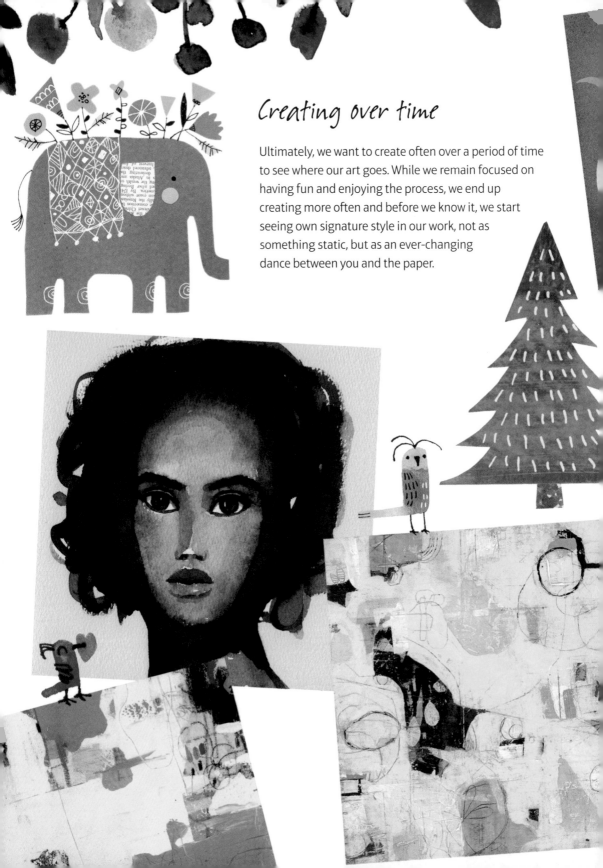

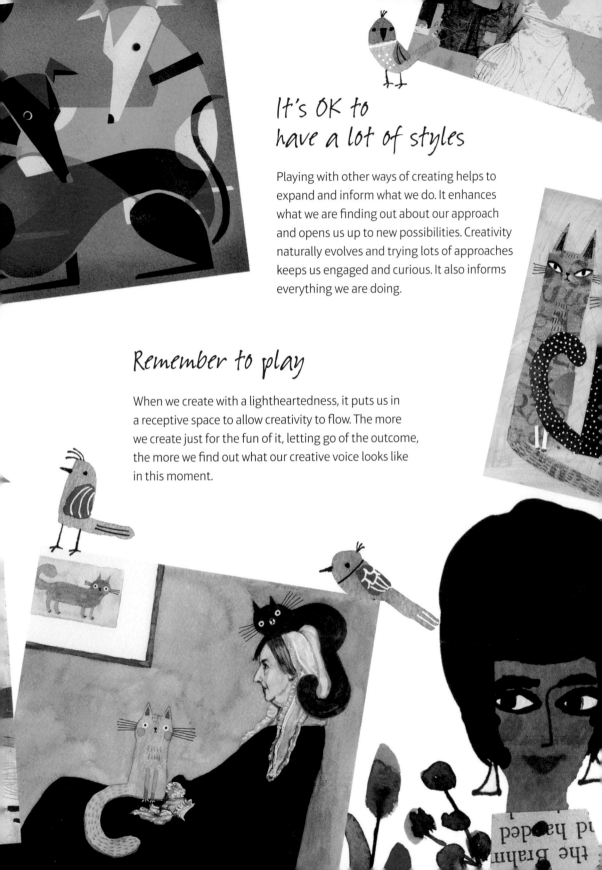

It's OK to have a lot of styles

Playing with other ways of creating helps to expand and inform what we do. It enhances what we are finding out about our approach and opens us up to new possibilities. Creativity naturally evolves and trying lots of approaches keeps us engaged and curious. It also informs everything we are doing.

Remember to play

When we create with a lightheartedness, it puts us in a receptive space to allow creativity to flow. The more we create just for the fun of it, letting go of the outcome, the more we find out what our creative voice looks like in this moment.

Every moment is new

In addition, remember that what you end up creating is not as important as the creative act itself. It is in the tiny moments, the upturn of the brush, the spreading of a wash, the discovery of a character, a lovely flower or an ugly duckling that we are uniquely expressing creativity. Any ideas otherwise (the inner critic) can float by without our engagement. No effort is required on our part to do anything with these old thoughts. They will dissipate likes waves in the ocean.

Reading and playing with the projects in this book is a beginning. Every moment is a new beginning. I hope that you will come back to this book often for ideas on where to focus and move with the flow. Let it inspire you and remind you that creativity is always present!

Creativity is the expression of joy, movement, and flow. It is you!

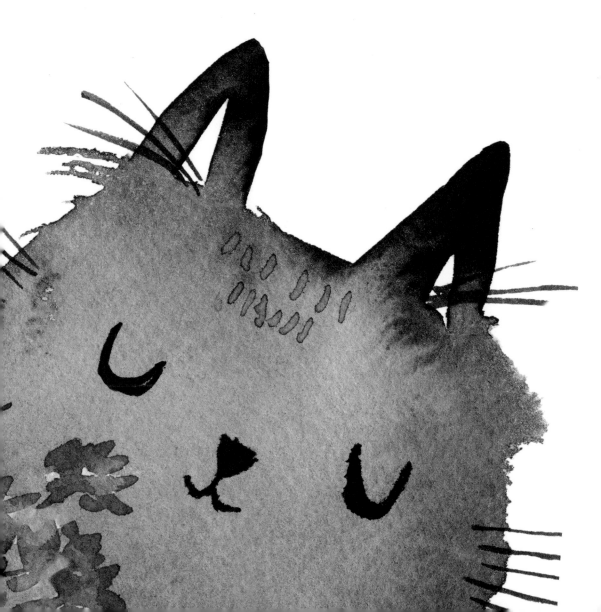

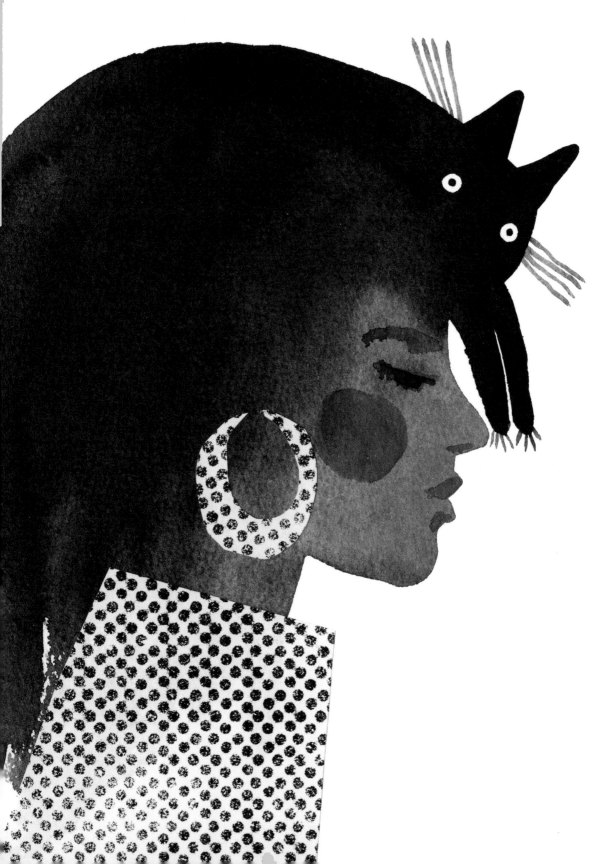

7

Final Thoughts

Watercolor is an amazing way to express your creativity. Each time you create a painting there is a new unseen mystery unfolding. Painting puts you in touch with your creative nature, which is found fully in the moment at hand, in present awareness. Remember that the inner critic only repeats what it knows from past ideas and memories. This does not make what it says true now. Now is a fresh clean moment, full of possibility. Also, you are here to explore and play, not to prove yourself. Painting is an expression of creativity and does not point to your value as a person.

Remember: your value is inherent, it is not earned. You are made of well-being and creativity no matter how your creativity expresses itself.

Have fun, play, and express your unique you!

Resources

WINSOR & NEWTON WATERCOLORS

- New Gamboge
- Lemon Yellow
- Scarlet Lake
- Alizarin Crimson
- Cerulean Blue
- French Ultramarine
- Yellow Ochre
- Burnt Umber
- Raw Umber
- Payne's Gray
- Green Gold
- Terre Verte
- Permanent White Gouache

WATERCOLOR BRUSHES

- Creative Mark Rhapsody Kolinsky Round #4–12
- Creative Mark Round #4–16

PALETTE AND PAPER

- Speedball™ Robert E. Wood Palette
- Fluid™ 100 Cold Press 100% cotton watercolor paper
- Canson XL 9 x 12-inch watercolor paper pad

DRAWING

- White Posca extra-fine marker
- Speedball® Crowquill Pen and India ink
- Black Staedtler Lumocolor® permanent marker (size S)
- 2B and 6B pencils
- Prismacolor Watercolor Pencil Set

SKETCHBOOK

- Strathmore Mixed Media 7.75 x 9.75 inches